To Virginia
with all best wishes –

Ernest Brommyer
1/91

This book, as well as others in the Insights to Art Series, is a reference book for students, teachers and artists. It is intended to show a wide range of visual expression and, as such, cannot be considered to be a complete reference. It can be the nucleus of a much larger collection of material that you may develop yourself, or you may use it to acquaint yourself with new and exciting forms of art. Photographers, painters, sculptors, craftspersons, students and museums have contributed work to show you how various artists look at **Landscapes.**

**insights to art**

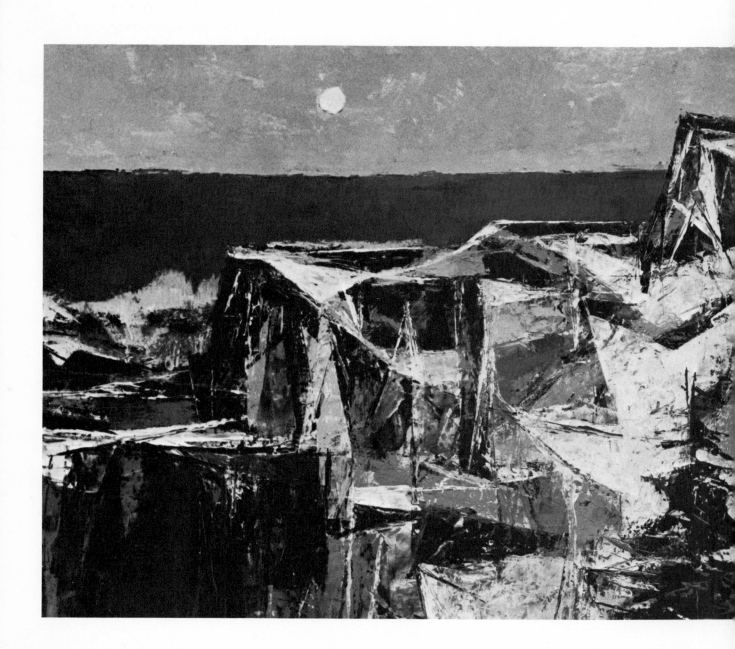

# landscapes

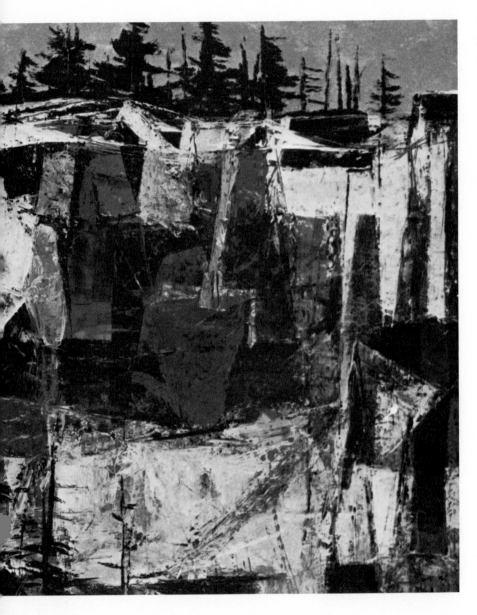

**Gerald F. Brommer**
*Lutheran High School*
*Los Angeles, California*

**Davis Publications, Inc.**
*Worcester, Massachusetts*

*To Walter Hellwege*
*geographer, teacher and friend,*
*who sensitized me to*
*the natural environment.*

Printed in the United States of America
Library of Congress Catalog Card
Number: 76-50508
ISBN 0-87192-086-7

*Printing:* Davis Press, Inc.
*Binding:* A. Horowitz & Son
*Type:* Helvetica
*Graphic Design:* Penny Darras and
Diane Nelson, Thumbnail Associates

*Consulting Editor:* George F. Horn

*Cover photos:* Neils Ibsen
*Title page photo:* *Winter Coast*
by Edward Betts, Collection of Mrs. J. Scott
Smart

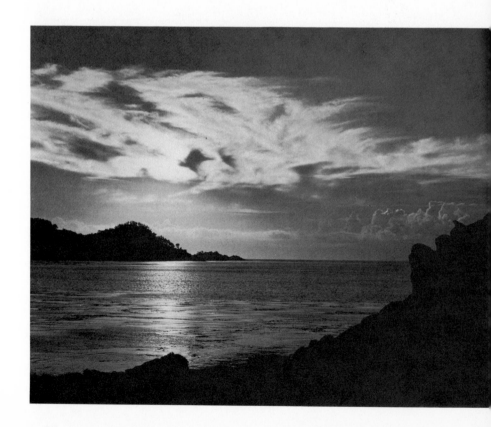

10  9  8  7  6  5  4  3  2

# contents

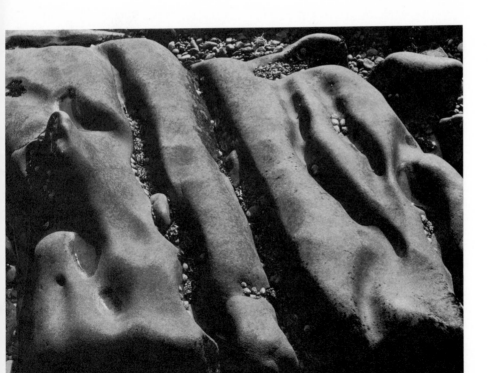

Photographs by Niels Ibsen

# introduction

Can you remember the last time you went through a forest or drove across a desert? Can you recall a time when you looked across a valley full of fields and trees? Do you remember the textures of beach sand or of stream pebbles on your bare feet? Can you bring to mind a beautiful sunset or sunrise; or the fragrant smells of a warm forest? Do storms, clouds and fog remind you of exciting times in your life? These are all experiences you have had with **landscapes.**

Rocks, sand, boulders and caves; trees, flowers, shrubs and grasses; streams, rivers, lakes and surf; mountains, mesas, hills and palisades; clouds, fog, mist and storms are all part of the landscape or the natural environment.

Perhaps you have taken photographs of some of these landscape features on your vacations. Professional photographers have trained themselves to see the excitement and composition of landscapes as revealed in our natural environment.

They train their cameras to catch the quiet, the drama, the texture or the violence of nature. Each sees the environment a bit differently than the others. Some are more conscious of color or form. Others emphasize drama, beauty, close-ups or large vistas. Each is recording nature through his or her own eyes and senses.

Painters and sculptors see the world in much the same ways, but they have the opportunity to use many more methods of personal expression. One painter might emphasize textures, another the organization of nature. Color and realism might inspire one artist, while another may enjoy the abstracting of nature's forms and shapes. Thick oil paint might appeal to you, but transparent washes might be the favorite technique of your neighbor.

There is no such thing as *the best way to paint a landscape!* Instead, there are many fascinating ways to paint landscapes. Several might not appeal to you at all, but there may be many that attract your attention.

Little children see the landscape elements in a different way than the mature professional artist. High school students express their landscape experiences in different ways than commercial artists. Rembrandt van Rijn painted what *he* saw and felt; and Winslow Homer painted what *he* saw and felt. Each artist sees and paints what he/she experiences, in a unique and personal way.

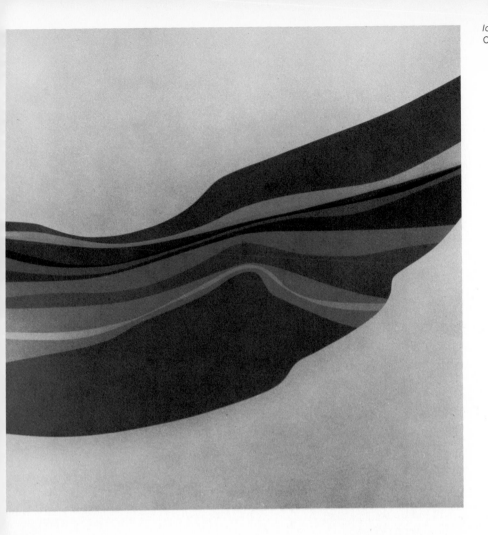

*Icarus Bay,* Helen Lundeberg. Acrylic on canvas. Collection of the artist.

Whether we use brush, pencil or a camera, we all see and record in personal ways. All are correct ways of communicating our feelings and sensations. Impressionist painters show us the color and light of outdoor scenes. Realists allow us to see intimate details. Hard-edge painters show us simplified shapes. Expressionists tell us about drama and feelings of excitement. All are telling us what they see and feel, and all are telling us the truth about landscapes.

Look over the material that follows in this book. Perhaps some of the landscapes will appeal to you — others may not. Some will excite you — others you may skip over for now. But in doing this, you will be helping yourself to understand your own feelings about landscapes, your natural environment and art. Enjoy the process of learning how various artists (including yourself) see the natural landscape . . . and keep your eyes open.

# the land

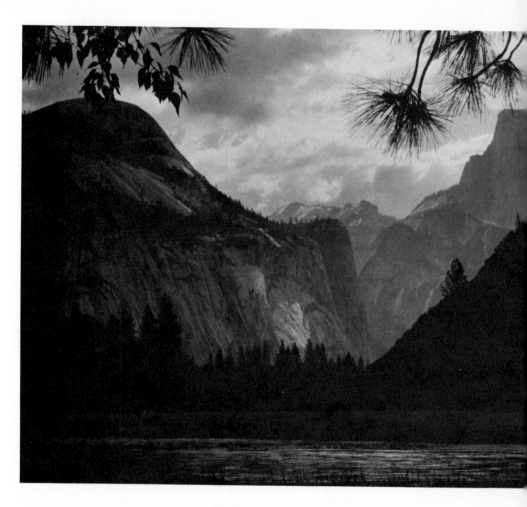

Deep valleys and canyons offer a view of the substructure of the land. Here, huge granite cliffs in the Sierra Nevadas thrust their shoulders into the sky. The vegetation has a softening effect on the monumental hardness of the rock.

*Yosemite National Park: North Dome.* Photograph by Niels Ibsen.

Landscapes cannot really be divided into separate elements, because land, water, vegetation and the atmosphere are usually present in various combinations. But it all begins with the land, which is the setting or stage on which the landscape arrangement is presented. Soil, sand, rocks, boulders, cliffs, mountains, hills, valleys and plains are the foundation material for landscapes.

Features of the land have been thrust up by tremendous movements of the surface. Erosion modifies these landscape features, and constant change is taking place. Huge earth forms are part of the landscape, but so are the smaller features, such as crevices, stones, mounds and ravines. Photographers and artists must become conscious of many land features, so they can use a variety of them in their work.

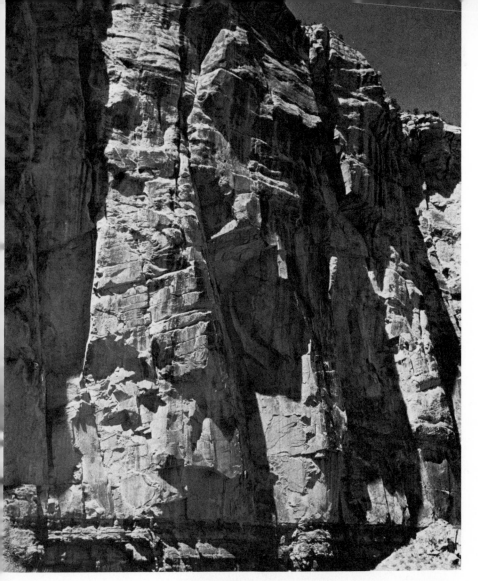

Although the huge canyon wall is an impressive landscape feature, the character is provided by the cracks and crevices which line its surface. Alternating shadows and sunlight produce interesting patterns and forms, breaking up the overall surface shape.

Photograph by Jack Selleck.

Although William Wolfram's collage, *Land Formations,* is non-objective in its intention, the artist has created a strong feeling of land and rocks, perhaps of subsurface textures. His earth-color materials help strengthen this impression.

Collection of Mr. and Mrs. Jack T. Ledbetter.

# cliffs

Vertical canyon walls have been cut from
the earth's bedrock by the violent action of
a river which is now resting from its work.
Such cliffs provide a view of the earth
several hundred meters below our feet.

Photograph by Jack Selleck.

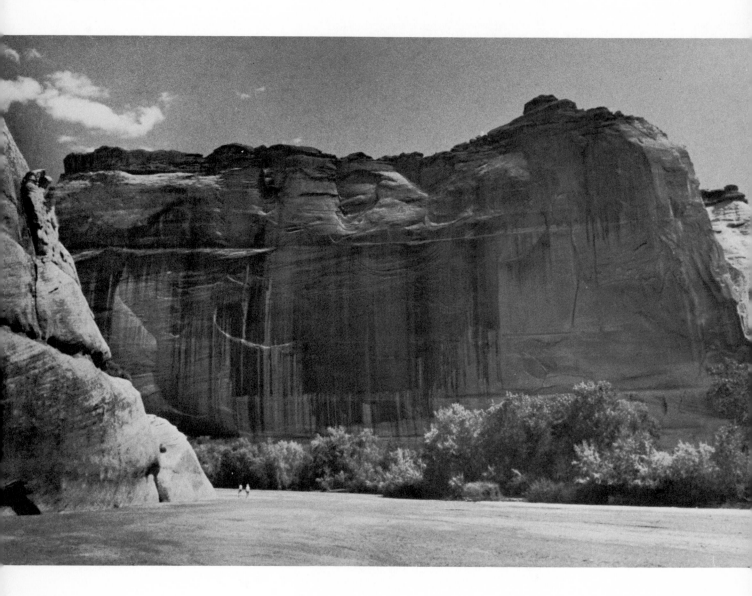

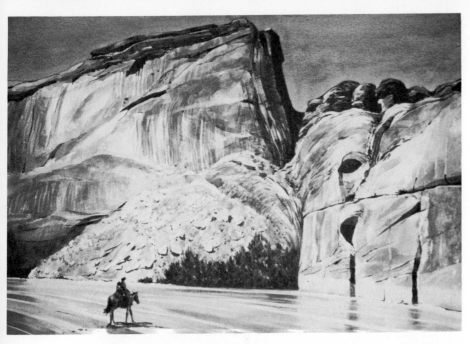

The red rocks of Canyon de Chelly have become shelter for some members of the Navajo Nation. The hardness of the rock is contrasted with the soft foliage and a glistening reflection. *Riding Home,* a watercolor by the author, uses a horse and riders to give a sense of size to the cliff.

Collection of W. G. Walker.

Rocks, boulders and subsurface strata are explored in Edward Betts' acrylic and collage painting, *Red Cliffs.* The artist has arranged the parts to form a personal interpretation of the landscape.

Courtesy of the artist.

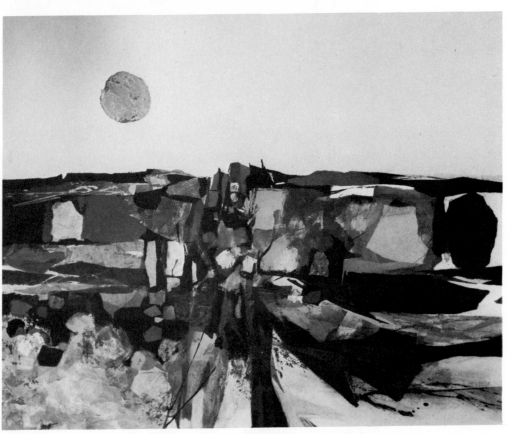

# rocks

Peter Voulkos sculpted *Gallas Rock,*
which creates the impression of a huge
stack of boulders. His outdoor work (1960)
is made of fired stoneware, with a natural,
earth-like finish, and is over eight feet
high.

Franklin D. Murphy Sculpture Garden, University of
California at Los Angeles, gift of Julianne Kemper.

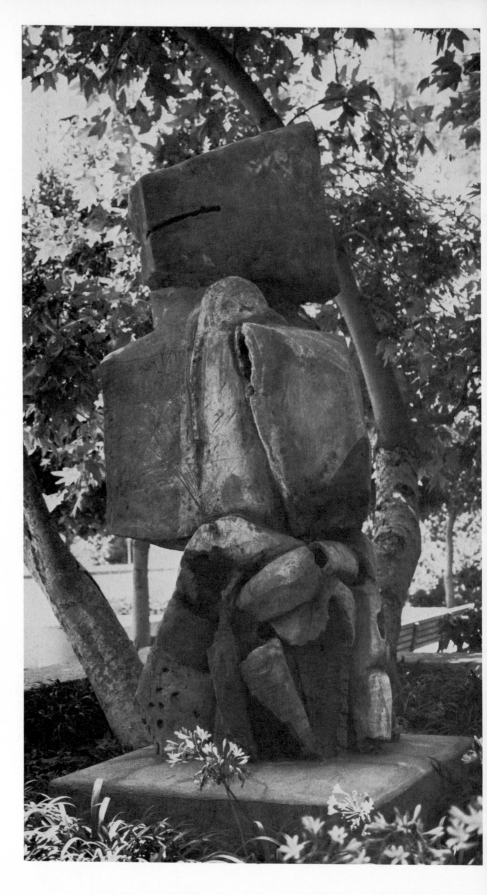

Rocks of various sizes (sand, pebbles, stones and part of the underlying bedrock) form a strong photographic composition. Textures and values add interest and help you see the forms of the rocks.

*Point Lobos.* Photograph by Niels Ibsen.

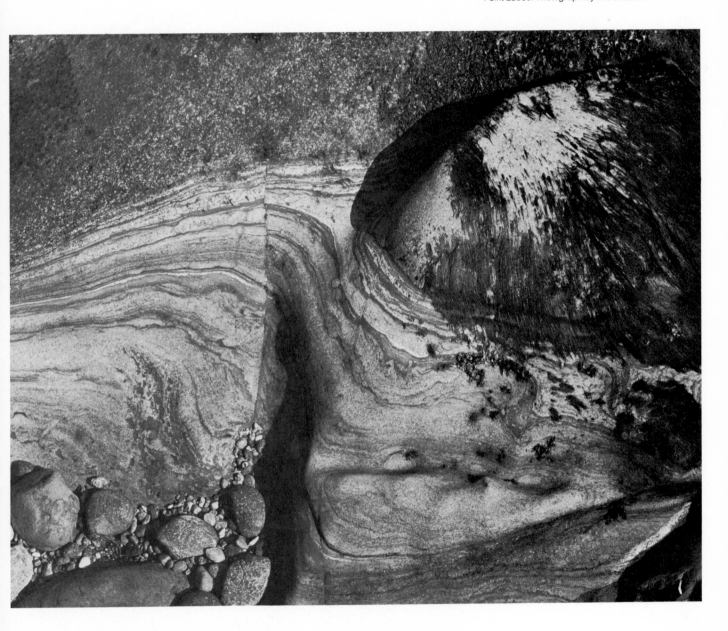

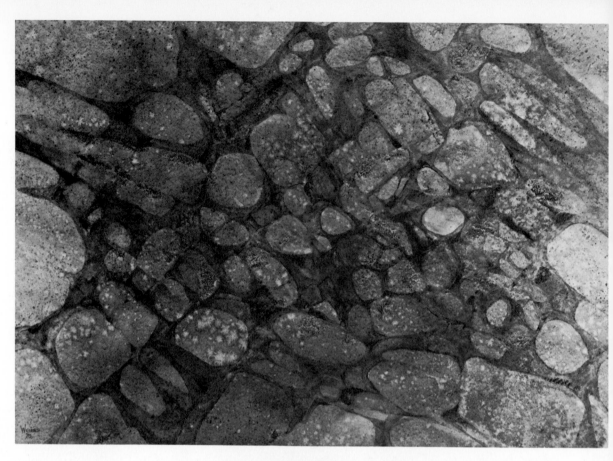

Smooth, water-worn pebbles are the sub-
ject of *Tidal Pool,* a watercolor by Lee
Weiss. Cool colors were used to enhance
the wet and shiny feeling of rocks under
water. Such a close-up look is a new way of
approaching landscape painting.

Collection of Maria Schmundt, courtesy of the artist.

The forms of rounded rocks show gradual
changes in value, but newly fractured
rocks have crisp edges, showing sharp
value changes. Notice the variety of
shapes, sizes and values on this moun-
tainside.

Photograph by Jack Selleck.

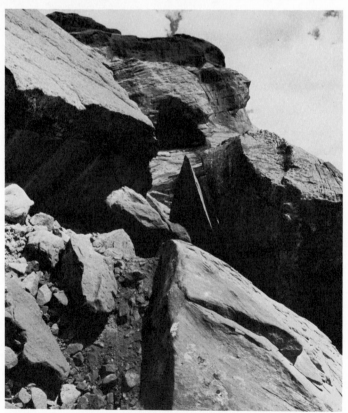

Dan Petersen's rocks are crisp and sharp-edged. In his watercolor, *Bare Season,* he makes use of thin, bare branches to provide a textural relief from the hard-surfaced rocks. Notice how snow softens the contours of some rocks. Can you see how the artist shows the difference between sharp and rounded edges?

Courtesy of the artist.

While some artists are concerned with the texture of rocks, Nick Brigante works with their forms, softened by wisps of fog. *Leaning Rocks* (1961) is almost monochromatic (one color) because the artist uses India ink washes. Three panels are combined to complete the painting, which is 76 inches high.

Courtesy of the artist.

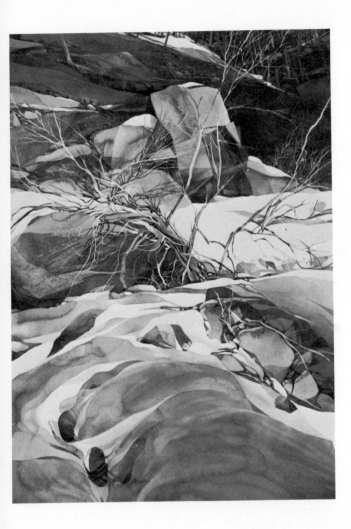

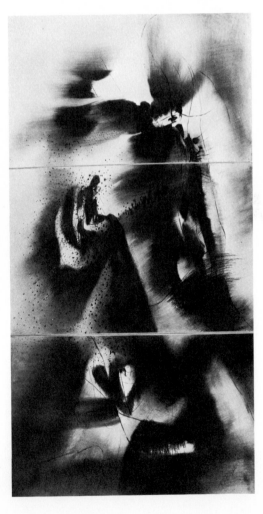

15

Some rocks are worn by wind and time; others have crisp edges and are newly broken from the cliff above. All of them are temporarily perched on the side of a rock hill. An occasional juniper tree softens the stark landscape.

Photograph by Jack Selleck.

Alexander Nepote sets a round rock at the edge of a cliff. His acrylic and watercolor painting uses collaged papers to achieve a rich textural surface. *Edge of the Abyss*, almost four feet square, is not an actual place, but the torn papers suggest rock forms to the artist.

Courtesy of the artist.

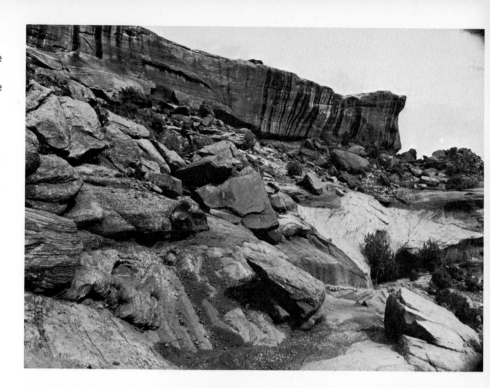

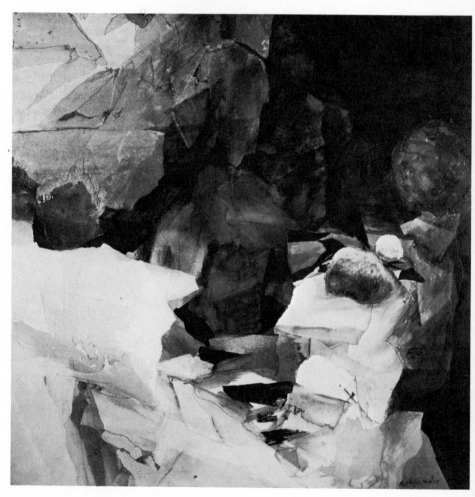

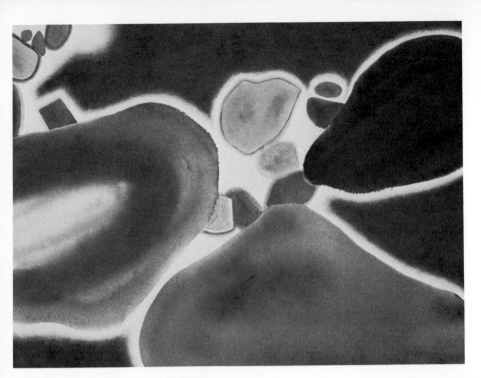

In his watercolor painting, *Tujunga Rocks,* Paul Souza has simplified shape, value and color to present a powerful abstract composition that began as a simple arrangement of rocks. The artist's painting style ranges from abstraction to realism.

Collection of Maria Magdalena Sanchez.

Doubling the image of huge rocks, Llyn Foulkes reinforces the concept of *form* in his 108-inch wide oil painting, *Rose Hill* (1964). The rocks are painted in a realistic manner, but the color (rose) is a personal statement by the artist.

Los Angeles County Museum of Art, Contemporary Art Council, New Talent Purchase Award.

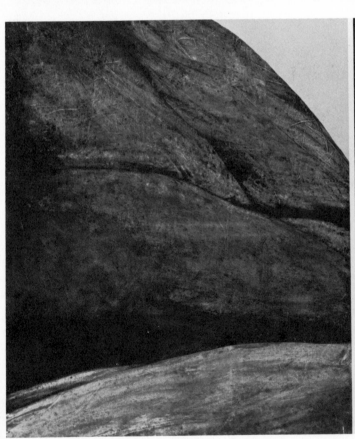 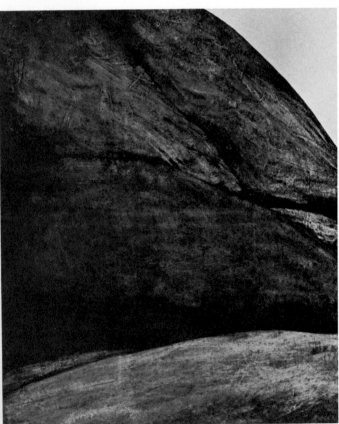

17

Rapid and fluid brush strokes were used by Phil Dike to create *Cormorant Rock,* yet the dark values produce a feeling of real solidity in the rocks. The artist has painted rocks and water many times, and has created a technique that is almost like a shorthand statement — quick, fluid, and full of meaning.

Courtesy of the artist.

Paul Cézanne began his oil painting, *Rocks in the Forest,* by looking at actual trees and rocks in the Forest of Fontainebleau. The artist balanced his design by moving and slanting trees and rearranging rocks. Squarish brush strokes are used in foliage and rocks to help unify the surface textures.

The Metropolitan Museum of Art, New York, the H. O. Havemeyer Collection, bequest of Mrs. H. O. Havemeyer.

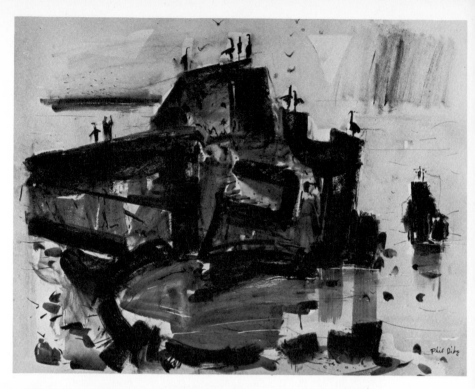

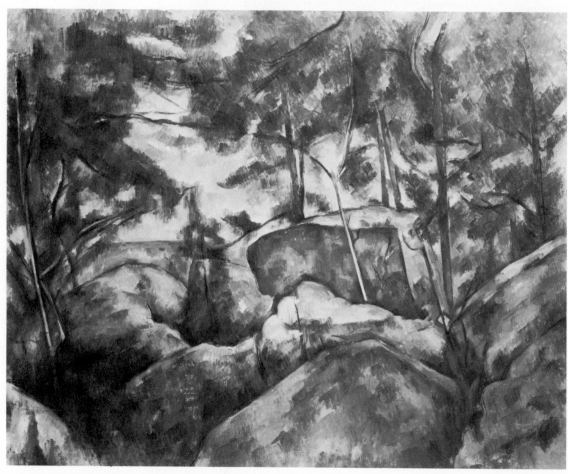

The stream, foliage and girl all help to soften the crisp feeling of sharp rectangular rocks in Robert E. Wood's *Girl by the Stream.* Strong value contrasts and texture help make the subject matter interesting. Squint your eyes to see the strong basic shapes which dominate the composition.

Collection of the artist.

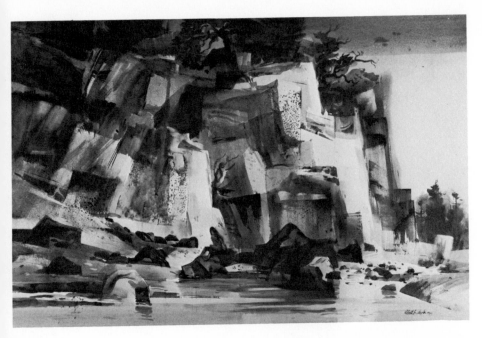

Watercolor and rice paper collage are combined in *Sun and Surf Series #3, Mendocino,* by the author. Texture and color range from detailed realism to simple abstraction, almost as if the painting were still being worked on. The abstract structural features of a landscape are revealed in techniques such as this.

Collection of Mr. and Mrs. Gene Yamasaki.

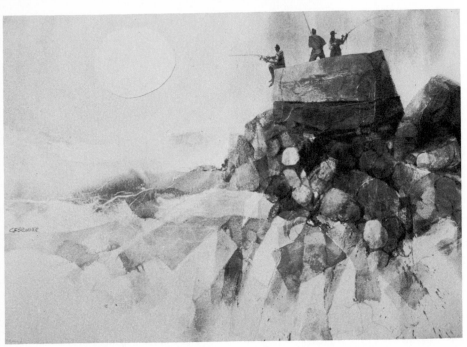

# hills and valleys

A small stream has cut its way through this shallow valley. Now it meanders peacefully through green meadows, flat hills and dense woods.

Some valleys have gently sloping sides, while others are dramatic and canyon-like. William Keith shows us *Yosemite Valley* as it appeared to him in 1875. Notice how the far walls of the valley appear distant while the river and trees are emphasized.

Los Angeles County Museum of Art, bequest of A. T. Jergins.

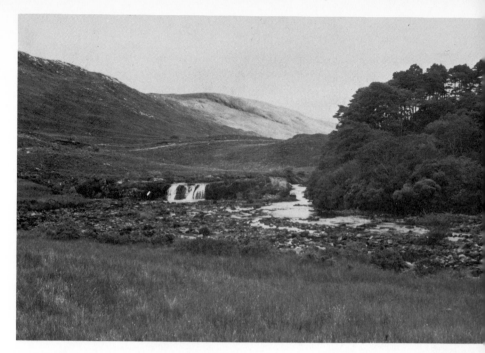

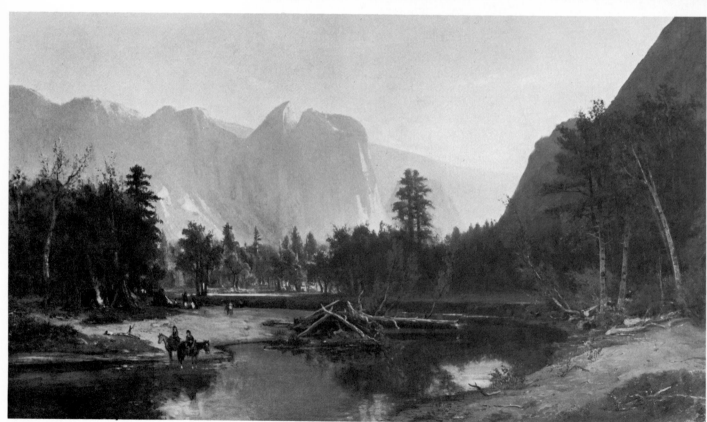

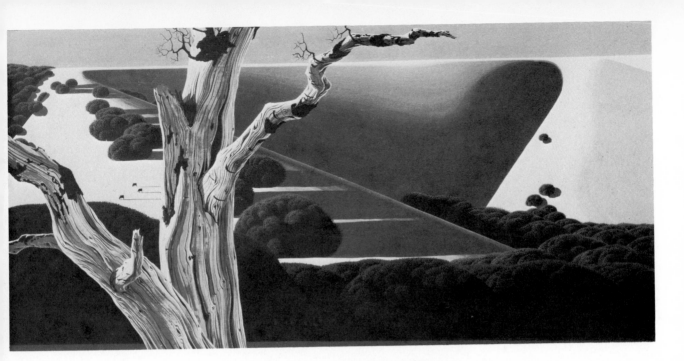

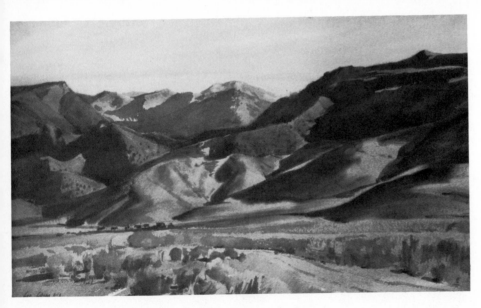

The careful selection of shapes, values, colors and style allows Eyvind Earle to abstract his landscapes in a very personal way. *Santa Ynez Valley,* an acrylic painting, not only shows you the valley in which the artist lives, but lets you see its design and composition through his eyes.

Collection of Joan and Eyvind Earle.

George Gibson conveys the feeling of the soft contours of the hills in his watercolor, *Hills — Emil's Valley.* The flat foreground leads into the hills, which are given the dominant position in the design. Shadows become lighter in value as the hills get farther away.

Courtesy of the artist.

# mountains

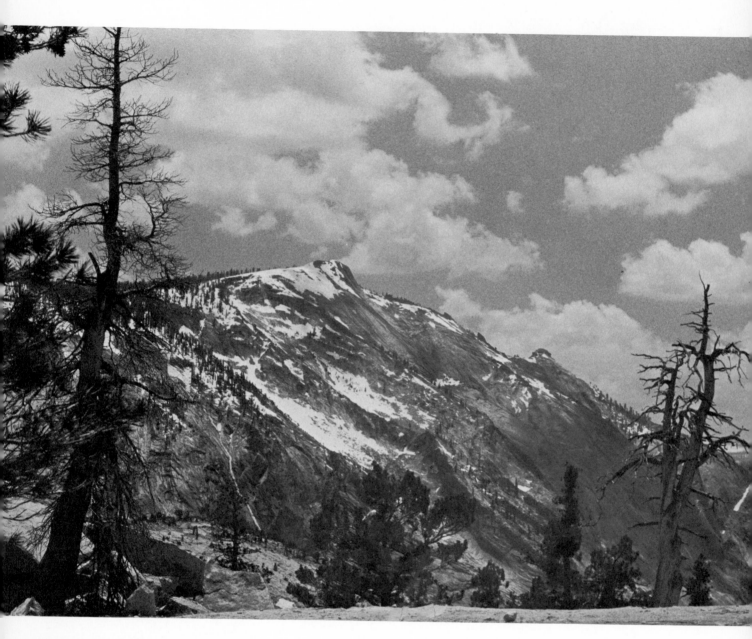

Mountains are the most conspicuous fea-
ture of our landscapes on earth. From a
distance, they lose their detail and peaks
sometimes disappear in the clouds.
Patches of snow help create a rugged
feeling, and a sense of great height.

*High Sierra.* Photograph by Niels Ibsen.

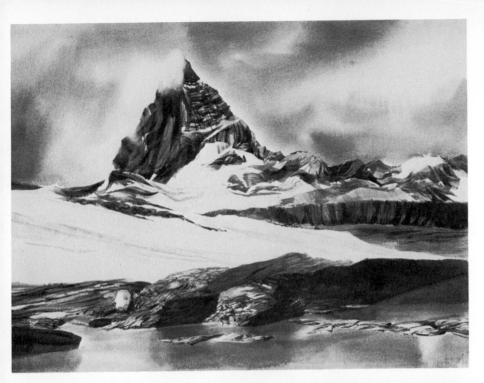

Snow and blowing clouds help obscure the textures of this alpine peak. *View of the Matterhorn,* by the author, uses simplified patterns to create the feeling of rocks and textures. The soft sky makes the sharp edges of the mountains seem more crisp.

Collection of Elizabeth Marshall.

Juicy acrylic paint was applied with painting knives to produce a heavily textured surface for this mountain painting. The student found that such a surface has a vibrating effect and gives life to the work.

Lutheran High School, Los Angeles.

Paper stencils were used as the block-out material in this silk screen print by a high school student. Simplification of textures and colors is necessary when only flat shapes are used.

Lutheran High School, Los Angeles.

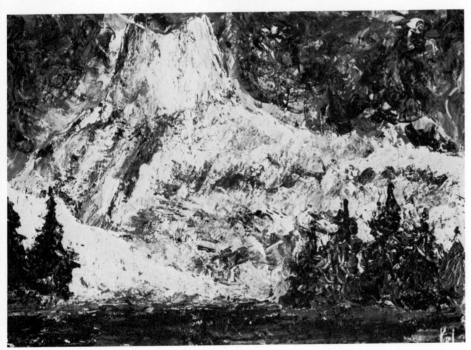

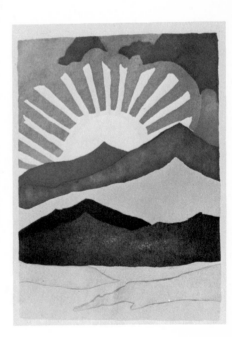

Glaciers, plus the action of freezing and thawing, often help determine the contour of many mountains. Younger mountains are more rugged and have sharper edges than older mountains, which have been worn down somewhat by erosion.

*Near the Jungfrau.* Photograph by the author.

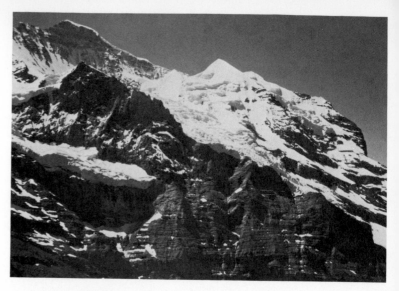

William Wendt leads our eyes over rolling foothills to the rocky surface of a pyramid-shaped mountain. *Where Nature's God Hath Wrought* (1923) shows powerful mountain forms painted with equally powerful brush strokes.

Los Angeles County Museum of Art, Mr. and Mrs. Allan C. Balch Collection.

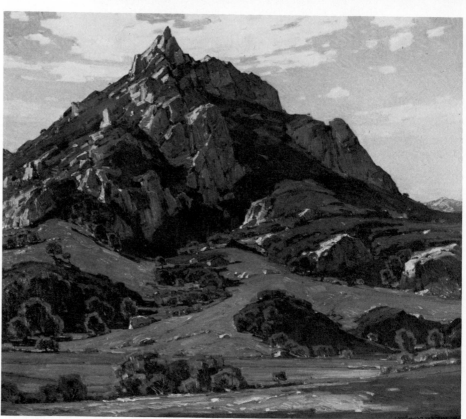

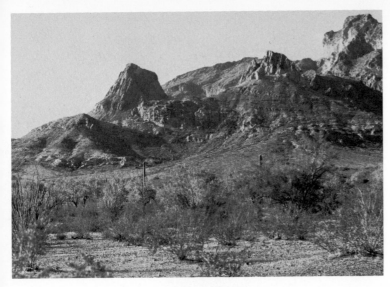

Mountains in desert regions may be sculpted into grotesque shapes by wind and blowing sand. Desert vegetation completes the dry landscape look. It is easy to see how this contrasts with mountain landscapes in more humid climates.

John Marin used the pyramid forms of mountains, which are static and solid, and transformed them into a dynamic and alive composition. *New Mexico Near Taos* (1929) is a watercolor in which simple shapes become exciting by their use and associations.

Los Angeles County Museum of Art, Mira Hershey Memorial Collection.

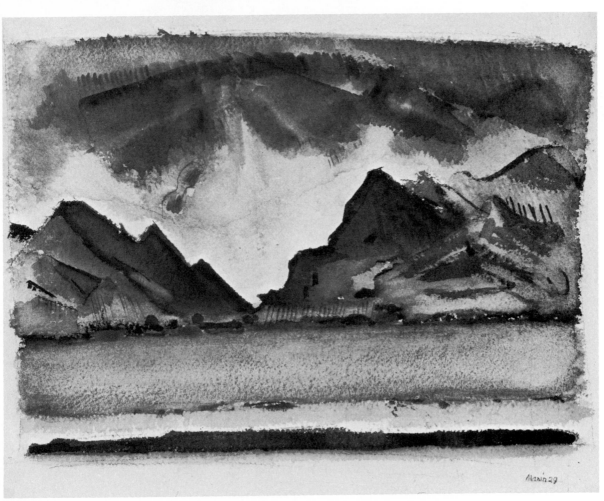

Erratic volcanic action can produce dramatic shapes in landforms. *Iao Needle* in Hawaii, is a lava spire which pierces the cloud-drenched skies over Maui.

Courtesy Hawaii Visitors Bureau.

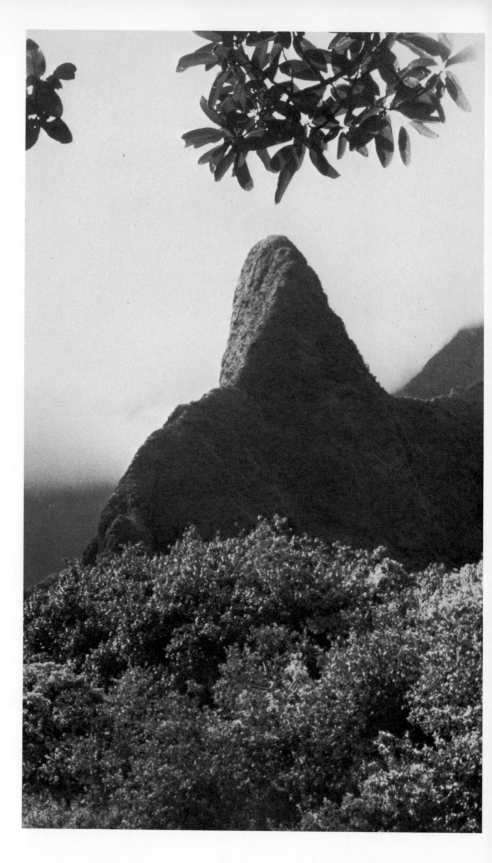

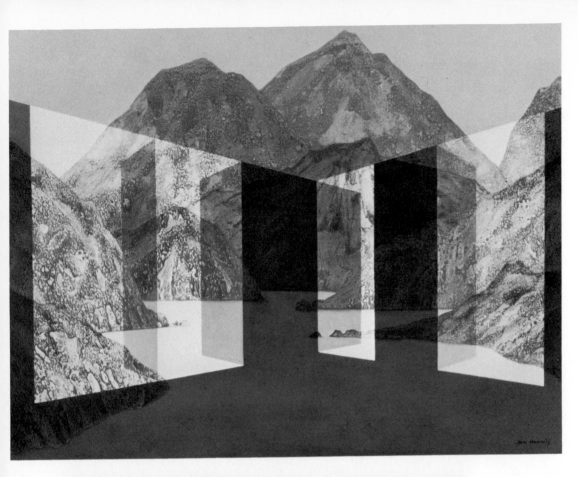

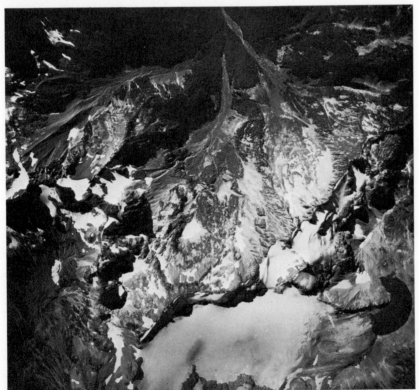

In *Doors of Perception, II,* Jan Hoowij is saying that there is more than one way to view mountains. Their textures are convincing and realistic, but the transparent doors are more important to the artist's message.

Courtesy of the artist.

Looking *down* on a mountain can give you a completely different concept than the normal horizontal view. This photograph was taken from 14,500 feet above and used infrared film to show trees, snow, rock ridges and a glacier (in Washington). Could you use this information in a painting?

Photograph, courtesy NASA.

# plains

Although the land is flat, the photographer (or artist) can see it from an elevated position. By use of a high horizon line (eye level), trees, bushes, water or other land-scape features can be emphasized in the foreground, while the sky can be reduced to a sliver on the horizon.

Courtesy Florida Department of Commerce.

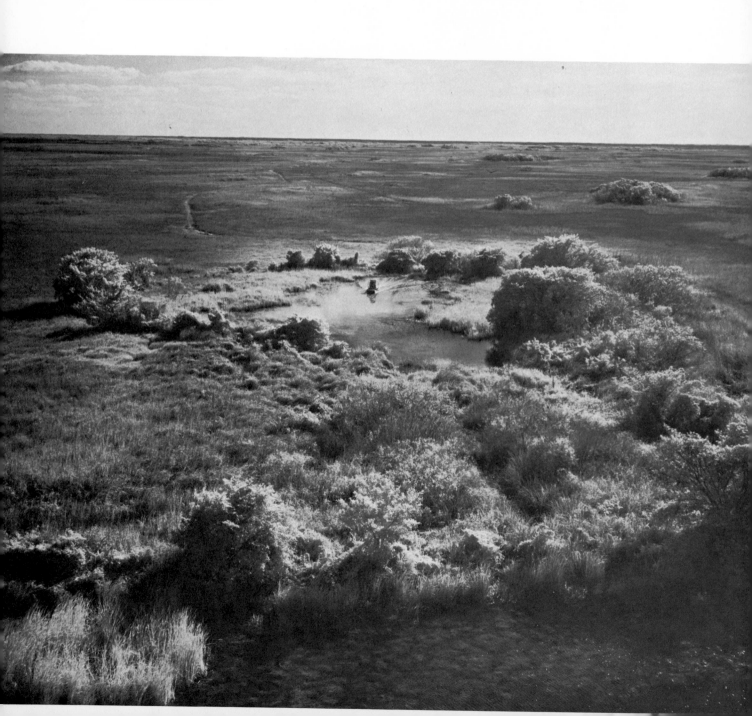

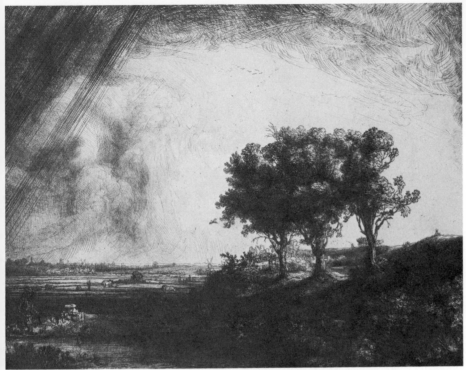

The plains of Holland are flatter than almost any others, but in his etching *The Three Trees,* Rembrandt van Rijn has made the foreground exciting. He placed three large trees at the right side and created a swirling sky that emphasizes the gnarled trees rather than the distant, flat plain.

The National Gallery of Art, Washington D.C.,
R. Horace Gallatin Collection.

Although the horizon line is flat, the textural treatment of vegetation adds interest in Tom Sellack's *Flat Horizon.* Pushing the eye level high in the design also produces a more exciting composition. The artist used collage and watercolor, and has cut and gouged the foreground to create his textures.

Courtesy of the Emerson Gallery, Tarzana.

Torn and cut paper stencils were used to simplify the hills and plains in this student serigraph. A high horizon line emphasizes the vast space, as does the simple and uncluttered treatment of the foreground.

Lutheran High School, Los Angeles.

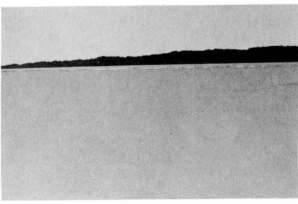

# vegetation

Trunks and branches of trees are the framework that supports the leafy foliage. When trees are bare, either by death or the annual shedding of leaves, this structure is clearly evident.

Gerald F. Brommer, in private collection.

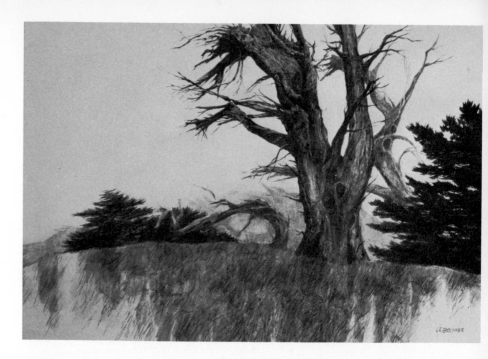

Although the land itself has many forms, it is further beautified by the various interesting plants that cover it. The vegetation in any particular part of our world adds to the character and feeling of that place.

Palm trees in Florida; pines and maples in New England; saguaro in the Southwest; mangroves in Louisiana; oaks and grasses in California's foothills; redwoods, beech and aspen; cactus, moss and reeds; shrubs, bushes and swamp growth; all are part of the vegetation pattern that covers much of the land surface.

Learn to look carefully at the characteristic *shapes* of the vegetation in your work area. Then notice its *textural feeling.* Try to find ways to create similar textures and shapes with the art tools you are using. Become aware of leaf patterns, shadow and light, and how masses of leaves create form and texture.

Notice how other artists and photographers see these textures and shapes, and how they use them to express the character of the landscapes in which they work.

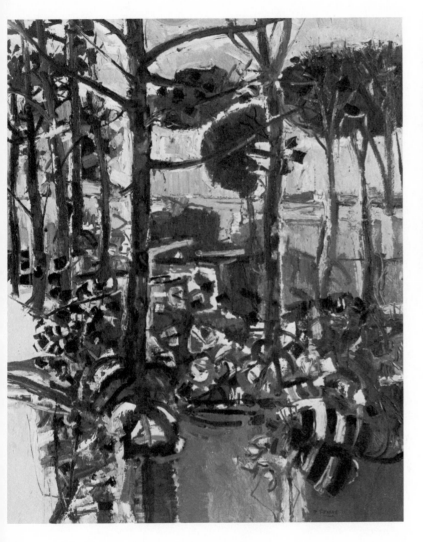

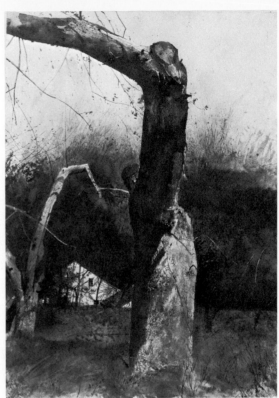

The textures of an awakening landscape set Andrew Wyeth to work on his water-color, *Early Spring*. The artist has carefully observed his environment and has created a textural quality in the tree and its surroundings. Much of the realistic appearance is produced by blotting and spattering to simulate actual textures.

Los Angeles County Museum of Art, gift of Maurine Church Coburn.

Tree trunks can be moved or slanted to produce the best design. In *Blue Trees*, Robert Frame uses trunks and branches to emphasize a vertical and horizontal pattern of color and line, producing a stained-glass window effect. He applies his oils heavily to create a richly textured surface.

Private collection, courtesy of the artist.

31

# trees

The twisted wreckage of a once-proud bristlecone pine still retains an eerie beauty. The powerful structure is evident in swirling textures that have resisted wind and weather for centuries.

Photograph by Niels Ibsen.

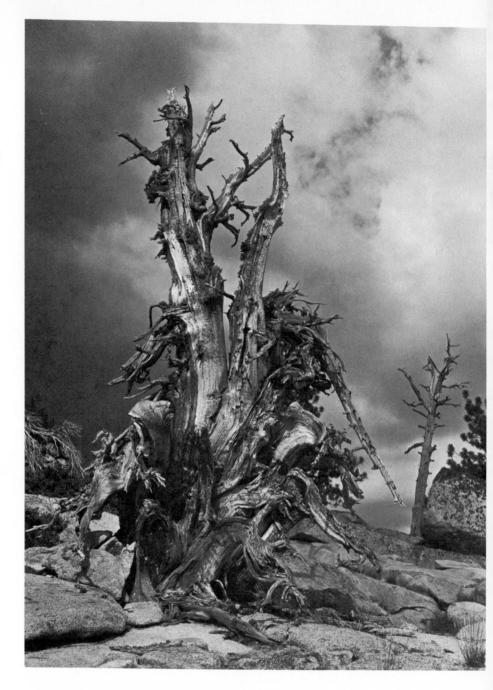

Contrasting values (dark against light; and light against dark) provide linear excitement in Michael Frary's watercolor, *Guadalupe*. Excess detail is eliminated and the emphasis is placed on simple shapes and colors.

Texas A and M University.

The linear pattern of massed trunks and branches creates an exciting environment in this woodcut by Richard Wiegmann. Notice the variety in the thickness of trunks and also in the sizes of the cut-out white spaces.

Collection of the author.

Using several different colored marking pens, this first grader drew a tree with massed foliage and a sturdy trunk.

St. Paul's Lutheran School, North Hollywood.

The twisted root structure of mangrove trees creates a unique environment in some swampy areas. Each tree has characteristics that set it apart from most others.

Courtesy Louisiana Tourist Development Commission.

The artist can stylize trees by altering their shapes or textures. Graham Sutherland uses his personal painting technique to design the shapes of *Thorn Trees*.

Albright-Knox Art Gallery, Buffalo, New York, room of Contemporary Art Fund.

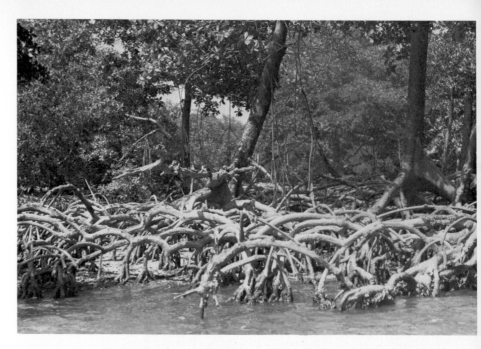

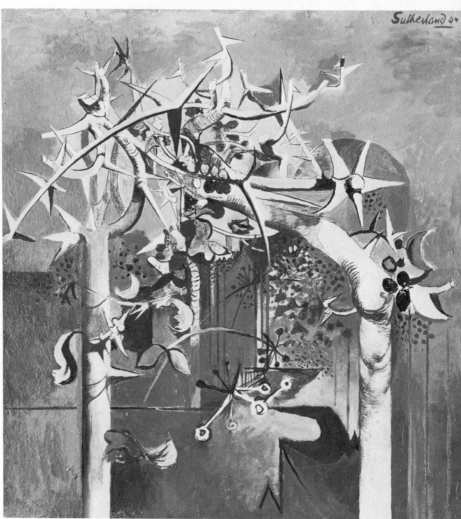

Albert Bierstadt used a vertical composition to emphasize the height of California's giant sequoias. His oil painting, *Redwood Trees* (1865), has several horizontal shapes and lines that keep the eye movement from running out the top and bottom of the painting.

Los Angeles County Museum of Art, gift of Dr. Robert G. Majer.

If you look carefully at trees, you might be able to figure out some basic shapes that characterize each type. Wayne LaCom uses some simple shapes to stand for the textures and forms of *Oasis Palm Trees*.

Courtesy of the artist.

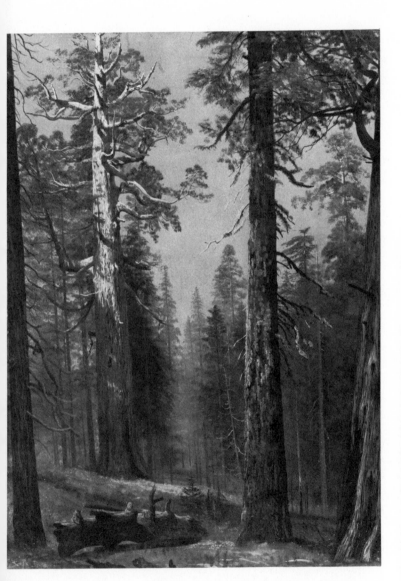

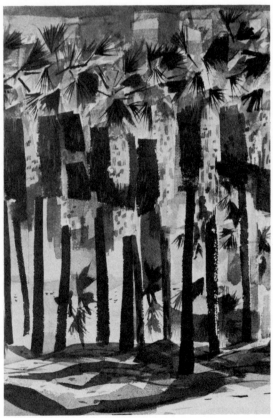

Soft masses of leaves and grasses are contrasted with hard and sturdy trunks and branches in this oil painting by the author. The see-through holes in many trees create an open feeling, while other trees have a more solid appearance.

Collection of Mrs. Georgia Brommer.

By massing foliage together, Henri Matisse did not have to paint individual leaves. His green brush strokes in *Les Gorges du Loup* change values to express the total forms of the trees.

National Gallery of Art, Washington D.C., Chester Dale Collection.

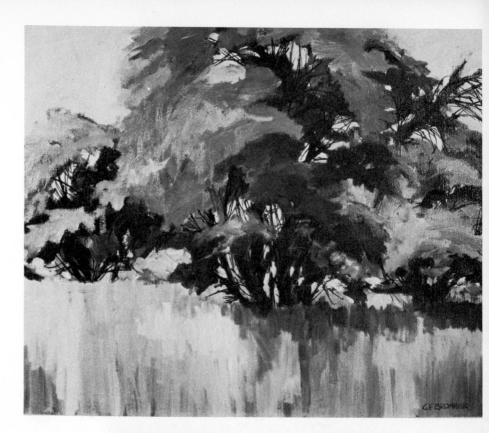

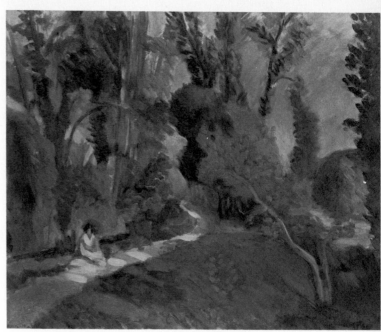

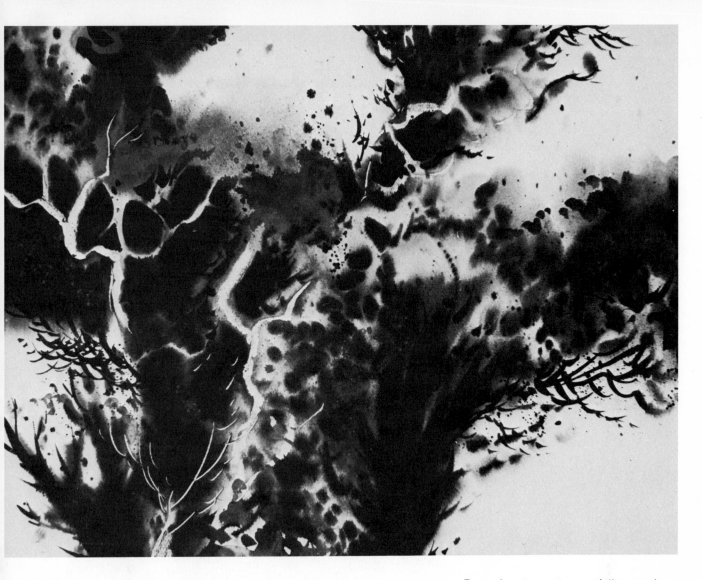

Roger Armstrong stresses foliage and branches, and directs your interest to only the top of the tree. Notice how he uses splashes, spatters and line to create the illusion of foliage, while strong value contrasts give a sense of the form.

Courtesy of the artist.

# foliage

Leaves can be studied individually or in masses. When looked at in masses, they tend to create a textural feeling, and artists capitalize on this as they develop their techniques for drawing and painting plants. The photographer can enhance his work by being aware of the varieties of textures in vegetation.

*Under the Ferns.* Photograph by Niels Ibsen.

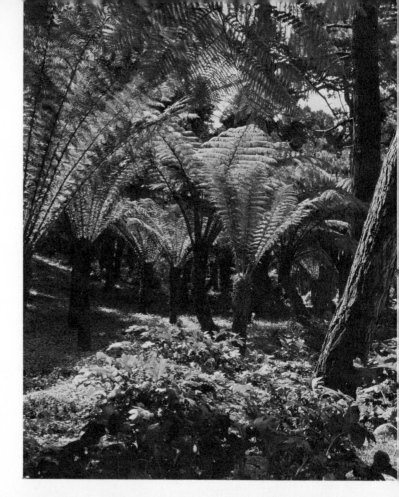

The textural quality of sunlight falling on foliage is shown by John Singer Sargent in his oil painting *Pomegranates, Majorca.* Squint your eyes to see the careful design of light shapes over darker values.

Los Angeles County Museum of Art, gift of Mrs. Stevenson Scott.

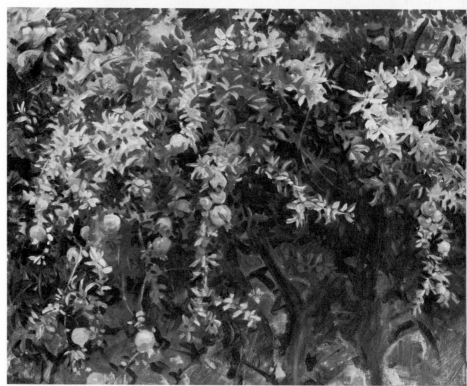

By spattering, dripping, slashing and pouring, Ray Friesz has produced a painting that has the feeling of landscape and foliage. His initial purpose in *Live Oak Canyon* is not to recreate an actual place, but to let his abstract arrangements *suggest* landscape features.

Courtesy of the artist.

Pen and ink were used by this high school student to create the textural feeling of massed foliage. Even though individual leaves were drawn, the appearance is similar to the textural feeling in natural vegetation.

John Marshall High School, Los Angeles.

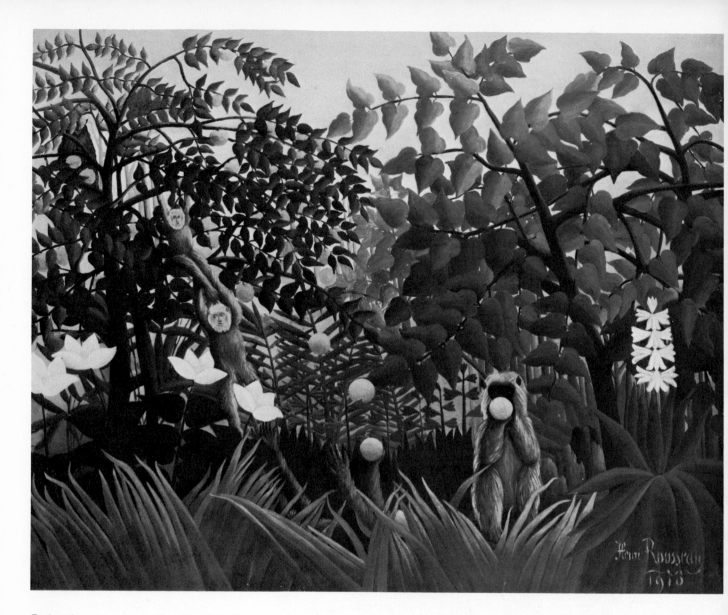

Rather than mass leaves together, Henri
Rousseau painted each one individually.
In *Exotic Landscape* (1910) he was fasci-
nated with the huge leaves found in jungle
locations. His primitive approach to art
produces a child-like treatment of detail.

Norton Simon Museum of Art at Pasadena, the Norton
Simon Foundation.

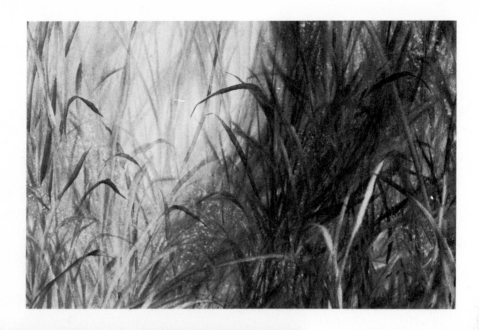

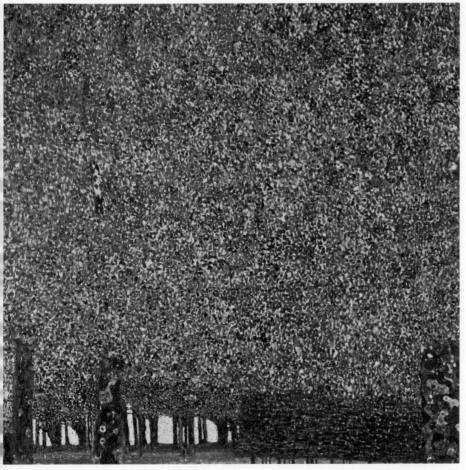

Close-ups of foliage can provide fascinating subject matter. In *Swamp Grass,* Lee Weiss paints a small patch of vegetation in large size (25 x 40 inches). She uses her unique watercolor style to show you an inside view of clumps of waving grass.

National Collection of Fine Arts, Smithsonian Institute.

In *The Park* (1910), Gustav Klimt painted the textures that are produced when sunlight falls on the surfaces of trees and shrubs. The more solid shapes (tree trunks and the figure) relieve the monotony of the masses of leaves.

The Museum of Modern Art, New York, Gertrud A. Mellon Fund.

Individual parts of vegetation can be explored, as in this view *through* the bobbing sea oats to the ocean beyond. Because of the location of the sun, the grasses are silhouetted against a lighter valued sky.

Photograph by Karl Holland, courtesy of the Florida Department of Commerce.

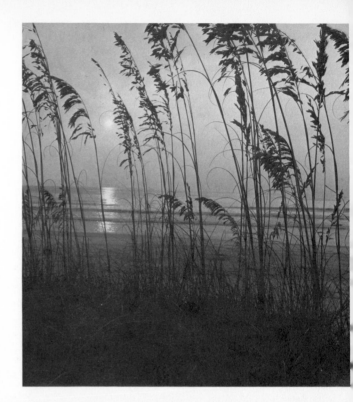

Sculptors may also work with foliage. Len Lye made *Grass* of stainless steel and wood, then motorized and programmed it to wave as if blown by some mysterious breeze.

Albright-Knox Art Gallery, Buffalo, New York, gift of Howard Wise Gallery.

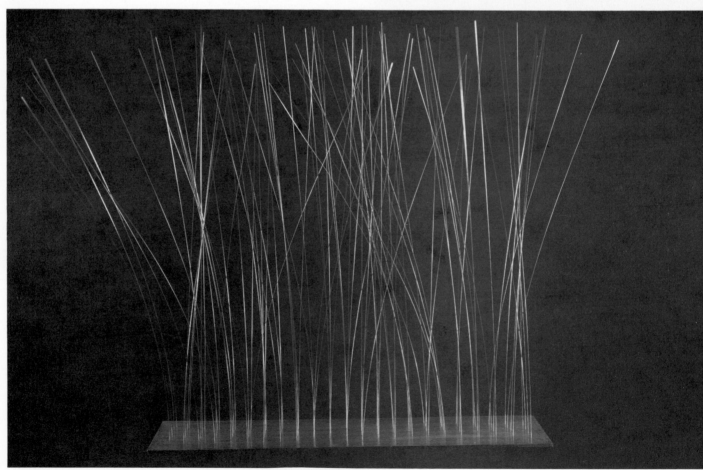

A hillside full of grasses, shrubbery and trees is reduced to simple patterns of color and light by Paul Souza. When you look at *White Cliff* with eyes squinted, you can imagine all sorts of vegetation.

Collection of Mr. and Mrs. Gerald Cohen.

Mary Jane Kieffer's watercolor of many types of foliage has an oriental quality. A great variety of green colors (together with their tints and shades) can be found in nature, if you are aware enough to see them.

*Foliage.* Collection of the author.

# flowers

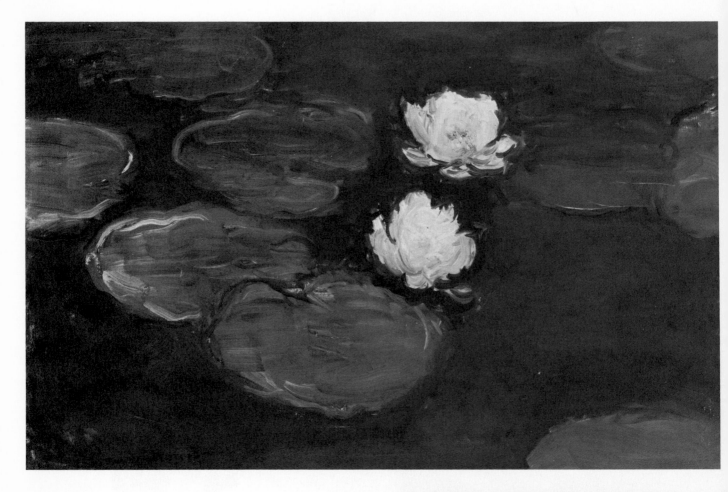

Though Claude Monet often painted flowers as masses of color and reflected light, he also treated them individually, as in *Water Lilies* (1903). Notice the simplicity and the contrast of values, which places emphasis on the blossoms.

Los Angeles County Museum of Art, bequest of Mrs. Fred Hathaway Bixby.

Not all flowers look like daisies or roses. A clump of pampas grass produces feathery blooms which wave delicately in the slightest breeze.

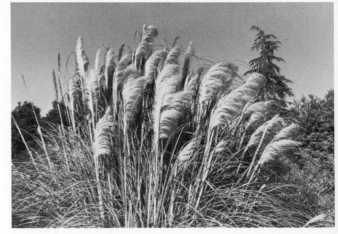

In his oil painting, *Springtime,* Delmer Yoakum uses a formal composition with strong rhythmic feelings. The flowers can be enlarged and emphasized due to their placement in the foreground.

Courtesy of the artist. Photograph by Cricklewood.

Flowers can be taken out of their environmental context and worked into abstracted shapes and patterns. This student serigraph shows such blooms, partially surrounded by a rainbow.

Lutheran High School, Los Angeles.

# fields

Sixteenth century painters used land-
scapes as a setting for their visual stories,
and Pieter Bruegel shows us the large
expanse of cultivated fields in his native
Flanders (Belgium). *The Harvesters*
(1565) is rich in the warm earth colors of
the fall season, and leads your eye with
large, graceful movements from fore-
ground into deep background space.

The Metropolitan Museum of Art, Rogers Fund.

Charles Hofmann's painting is really a
portrait of a farm and its buildings. The
primitive feeling is typical of many of
America's early unschooled, but talented,
artists. *View of Benjamin Reber's Farm*
(1872-1878) is complete to the tiniest de-
tail.

National Gallery of Art, Washington D.C., gift of Edgar
William and Bernice Chrysler Garbisch.

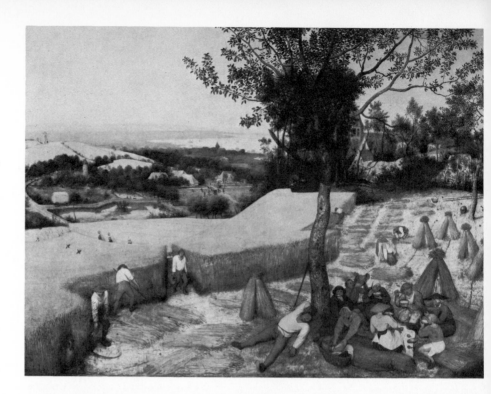

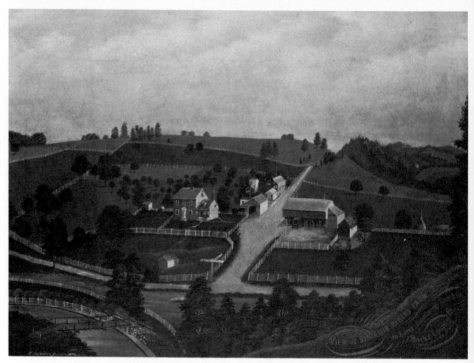

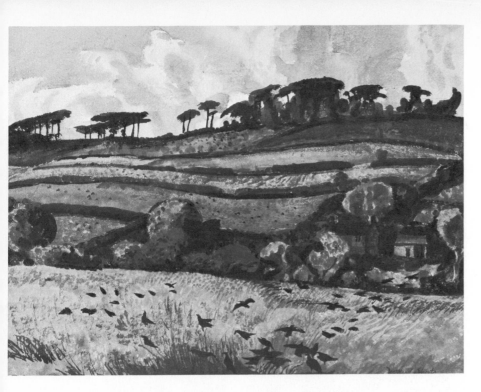

Green hedgerows separate individual fields in Millard Sheets' watercolor, *Fields near Middleton, Ireland*. The artist uses birds and trees to help direct your eye over the verdant hills of Ireland.

Courtesy of the Dalzell Hatfield Galleries, collection of the artist.

Rectangular-shaped fields caused Robert Patrick Rice to design his oil painting using vertical and horizontal lines and shapes. *Summer Road* gives you a different perspective while looking at fields in the landscape.

Collection of the artist.

Various textures were cut into linoleum to create this print of fields and fences. A look at other paintings on this page will help you see how this student selected textures and shapes to visualize the cultivated landscape.

Lutheran High School, Los Angeles.

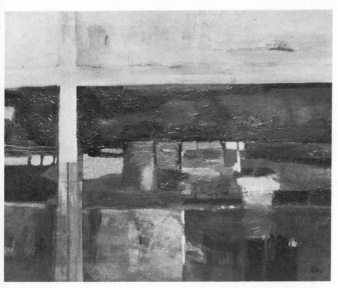

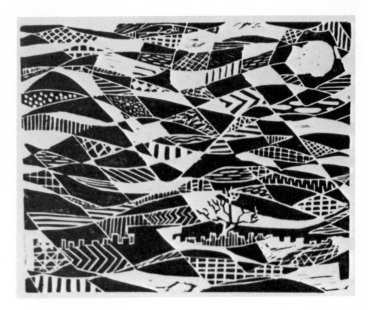

# cactus / deserts

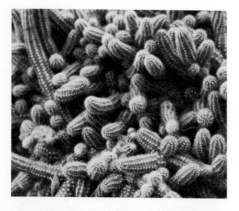

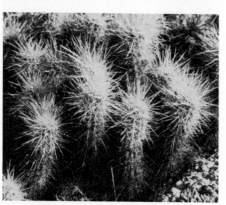

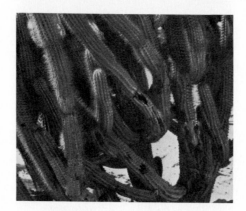

Cactus and succulents are vegetation found in desert areas of the world. A knowledge of their textures will help you when you begin to use them in your paintings, drawings or collages.

Typical shapes of cactus and desert mountains are combined in a vivid landscape of collaged tissue paper. Many warm colors were used to help create the warmth of most desert landscapes.

Lutheran High School, Los Angeles.

48

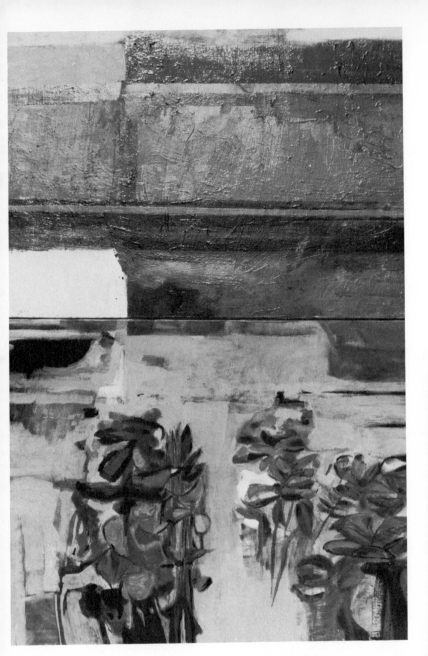

By placing small clumps of vegetation in the foreground, Robert Patrick Rice emphasizes the bare vistas of rock and sand found in most deserts. *Low Desert,* an oil and mixed media work, stresses the bleak yet colorful appearance of all deserts.

Collection of the artist.

The shape of a giant saguaro is silhouetted against a glowing moon and filmy clouds, in this dramatic desert photograph. The shapes and textures of desert vegetation are different from those of plants found in more moderate climates.

Photograph by Niels Ibsen.

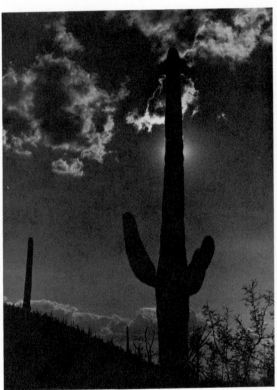

# water

The dense foliage of tropical vegetation provides the setting for this ribbon-like waterfall. Tumbling water appears white as it is dashed against rocky surfaces.

Courtesy Hawaii Visitors Bureau.

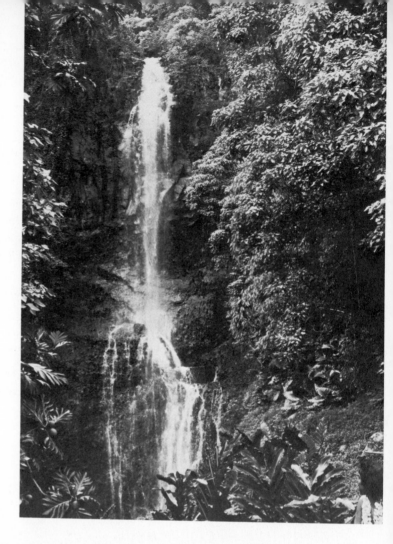

The rains fall, and water soaks into the waiting earth or slides off into rivulets which seek lower ground. Springs release water from the earth into streams, creeks, rivers, lakes and oceans. Water can lap gently against the shore or can beat wildly against rocks or soil. It can move slowly or swiftly, or stand almost motionless.

Since water (in its liquid state) is almost always in motion, it adds a sense of action to our landscapes. But this very characteristic might make it difficult to translate to paper or canvas.

Water can be seen as frothing cascades, tumbling falls, trickling streams or the shimmering surface of a pond or lake. It might be shown as reflections of the surrounding environment or as crashing surf on beaches or coastal boulders.

The variety of ways that water can be studied in nature is reflected in the many ways that artists show water in their photographs, paintings, drawings or prints.

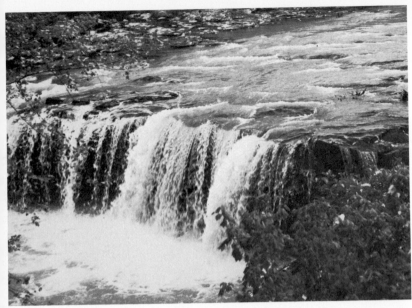

Steep drops in the land surface provide places for rivers or streams to flow in cascades or falls. Gentle streams can suddenly become powerful torrents, as the force of gravity pulls the water to the earth itself.

Courtesy Arkansas Department of Recreation and Tourism.

The translucent quality of cascading water is achieved by collaging rice paper over watercolored areas. A similar treatment (rice paper collage and watercolor) is used on the boulders that line the waterway in *Ten Mile Creek*, by the author.

Collection of Mr. and Mrs. William Sornborger.

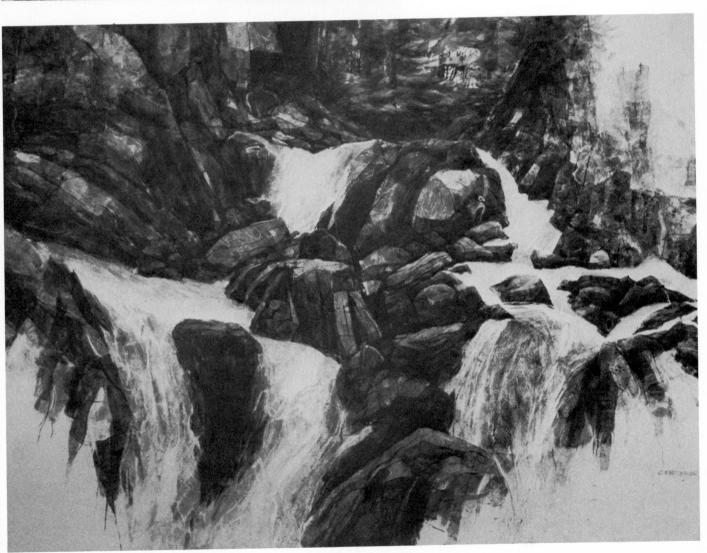

# rivers

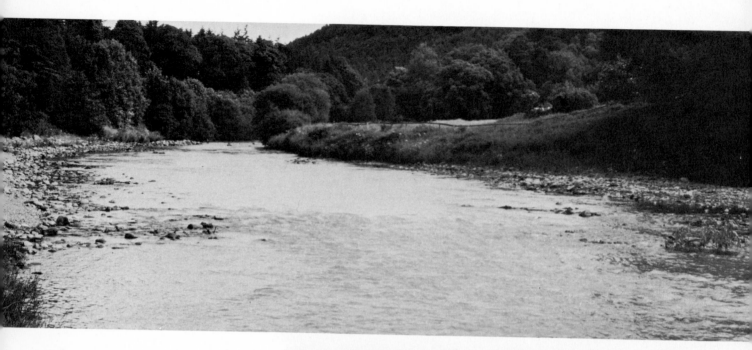

Notice how the camera catches the horizontal ripplings on the surface of a flowing river. Depending on the position of the sun, the water might seem either light or dark in value.

Winslow Homer shows us both slow moving water and a tumbling cascade in his watercolor, *The Rapids, Hudson River, Adirondaks* (1894). Notice how the horizontal eye movement corresponds to the directional flow of the water, from right to left.

The Art Institute of Chicago, Mr. and Mrs. Martin A. Ryerson Collection.

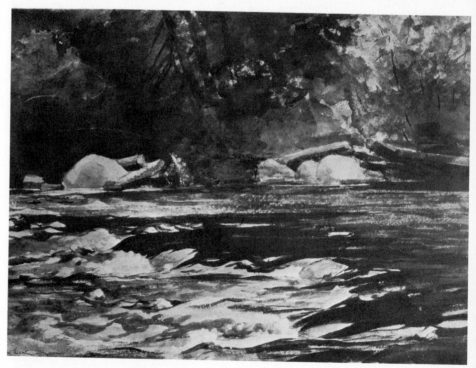

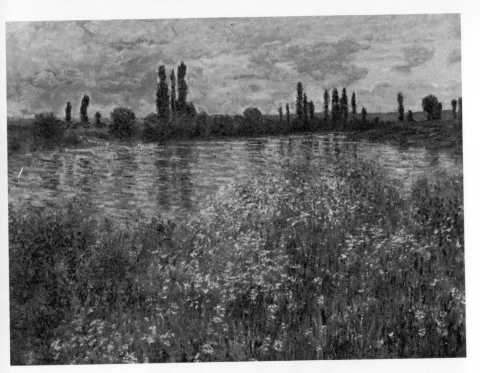

Impressionist painters were fascinated by light reflecting off the rippling surfaces of water. Claude Monet, in *Banks of the Seine, Vétheuil,* surrounds his reflective surface with soft flowers, trees and clouds.

National Gallery of Art, Washington D.C., Chester Dale Collection.

Robert Patrick Rice chose to emphasize the bank of the river rather than the water itself. In *Yuba River,* he has carefully selected and rearranged the various parts of his subject to show us a carefully ordered composition.

Collection of the artist.

The mighty Mississippi River (flowing through Louisiana) seems to be a meandering ribbon, when viewed from a Skylab space station in earth orbit. Such views might suggest new ways for you to use rivers in your paintings.

Photograph, courtesy NASA.

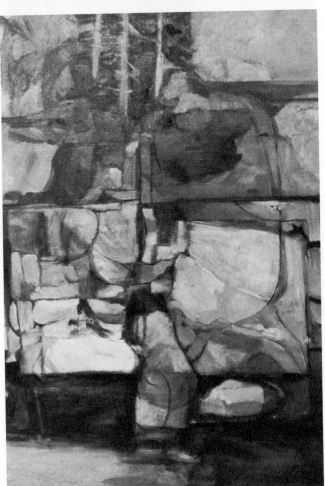

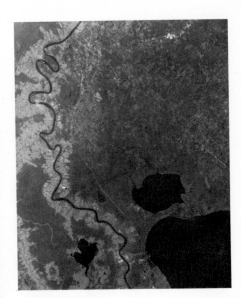

# ponds

The still water of a protected pond usually shimmers with reflected values, both dark and light. Small ripples will interrupt a perfectly reflected image and fracture it into small bits.

Courtesy Connecticut Department of Commerce.

Simplified shapes and forms characterize Michael Frary's watercolor, *Time of the Loon.* Reflected images become simple wiggly lines that give a shimmering feeling in the water of this pond.

From *Impressions of the Big Thicket,* courtesy of the artist and the University of Texas Press, 1973.

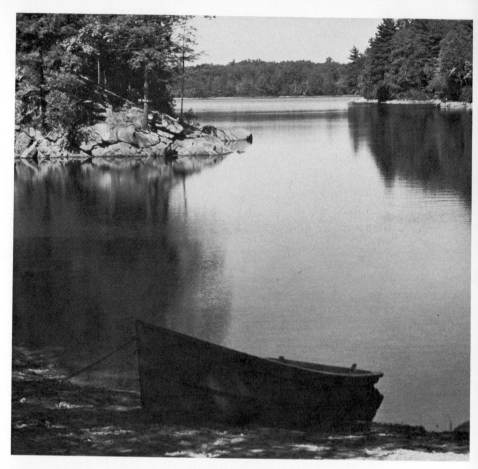

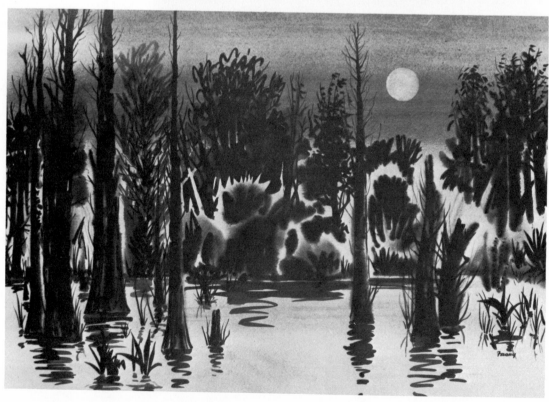

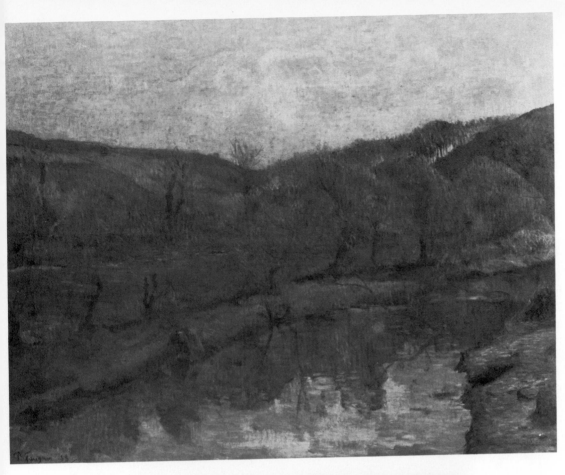

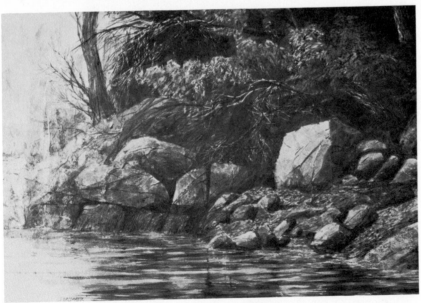

Paul Gauguin used definite brush strokes to add texture to his oil painting, *Brittany Landscape*. This technique lends itself well to an impressionistic view of reflections in pond water.

National Gallery of Art, Washington D.C., Chester Dale Collection.

The rocks and trees that line the edge of this pond are featured more than the water itself, yet the glistening surface provides the life for the subject. Watercolor and collaged rice paper were used by the author to portray this foggy autumn morning.

Collection of Susan Hennis.

# lakes

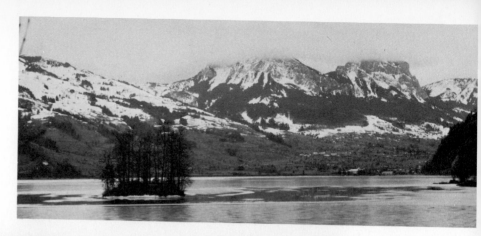

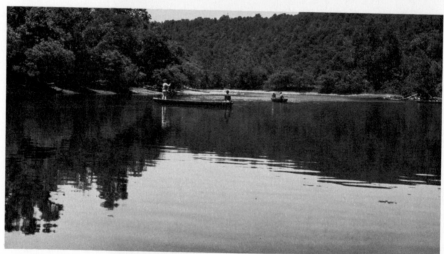

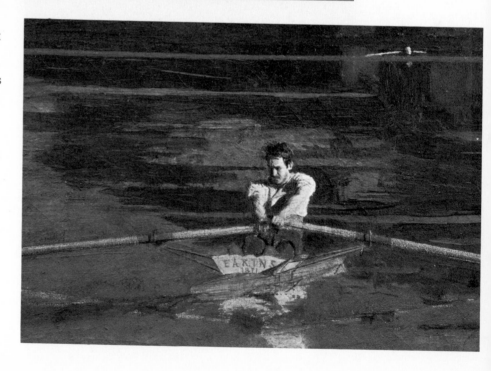

An icy winter lake contains a small island which becomes the center of interest, as it is silhouetted against a lighter valued background. What colors would emphasize the chilly feeling you get from this photograph?

Focusing on a small part of this lake, the photographer has used boats and trees to heighten interest. Notice the horizontal line quality in the slightly-disturbed surface of the water.

Courtesy Arkansas Department of Parks and Tourism.

Thomas Eakins focused on a close-up of action in the water in *Max Schmitt in a Single Scull* (1871). Looking down on the water for a more interesting perspective, the artist uses the surrounding water as a background for the rower.

The Metropolitan Museum of Art, Alfred N. Punnett Fund and gift of George D. Pratt.

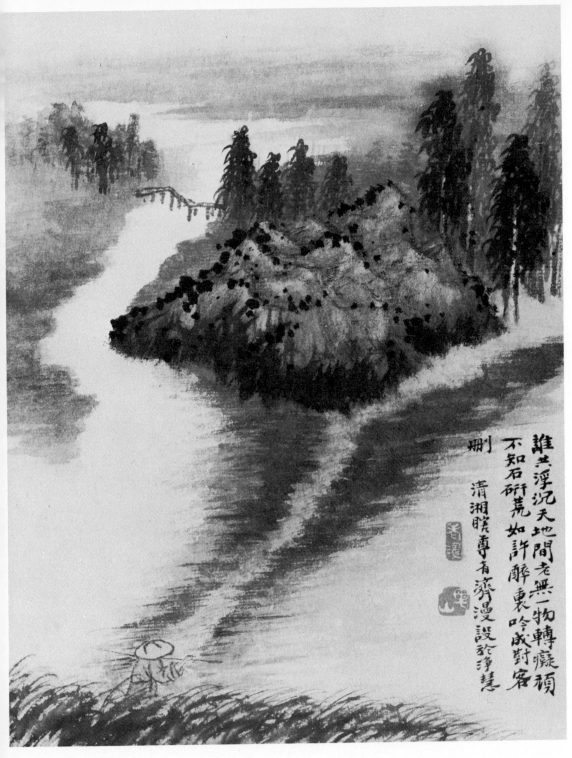

離共浮沉天地間老無一物轉癡頑
不知石罅荒如許醉裏吟成對客
刪　清湘瞎尊有滌漫設於淨慧

Chinese artist, Tao-chi used islands, trees
and a bridge to fill the lake with interesting
objects. This view is one page of an
eight-page drawing series, called *Album
of Landscapes* (1694).

Los Angeles County Museum of Art.

# reflections

Perfectly still water provides a mirror-like
surface which reflects a perfect inverted
image. Such conditions rarely exist in na-
ture, since wind and people can easily
disrupt surfaces.

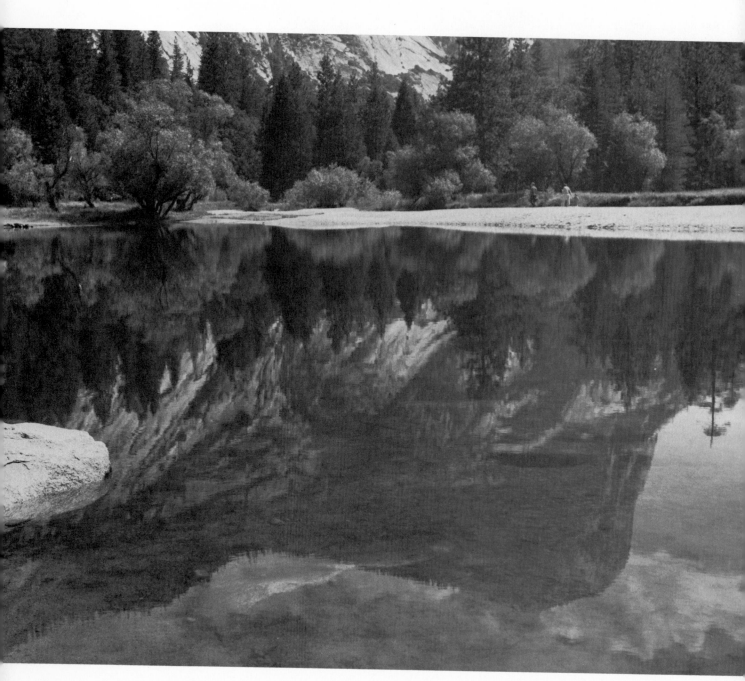

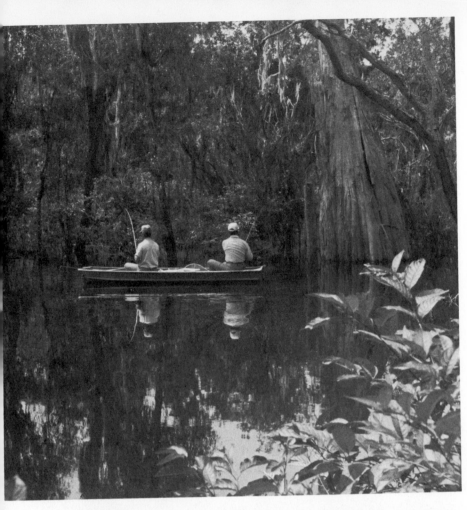

The calm waters of a Louisiana bayou reflect the lush vegetation which surrounds it. Several fishermen and their boat become a focal point in the scenic landscape.

Courtesy Louisiana Tourist Development Commission.

The rippling surface of this water produces a distorted image of the island and its trees. The more active the water, the more fractured the reflected image becomes.

*North Island Reflection.* Photograph by Robert W. Cooke.

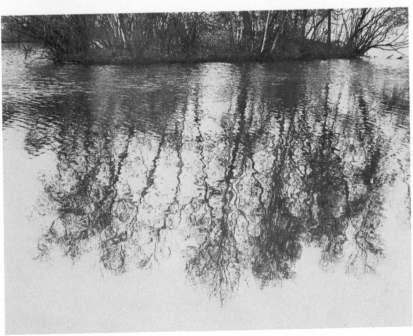

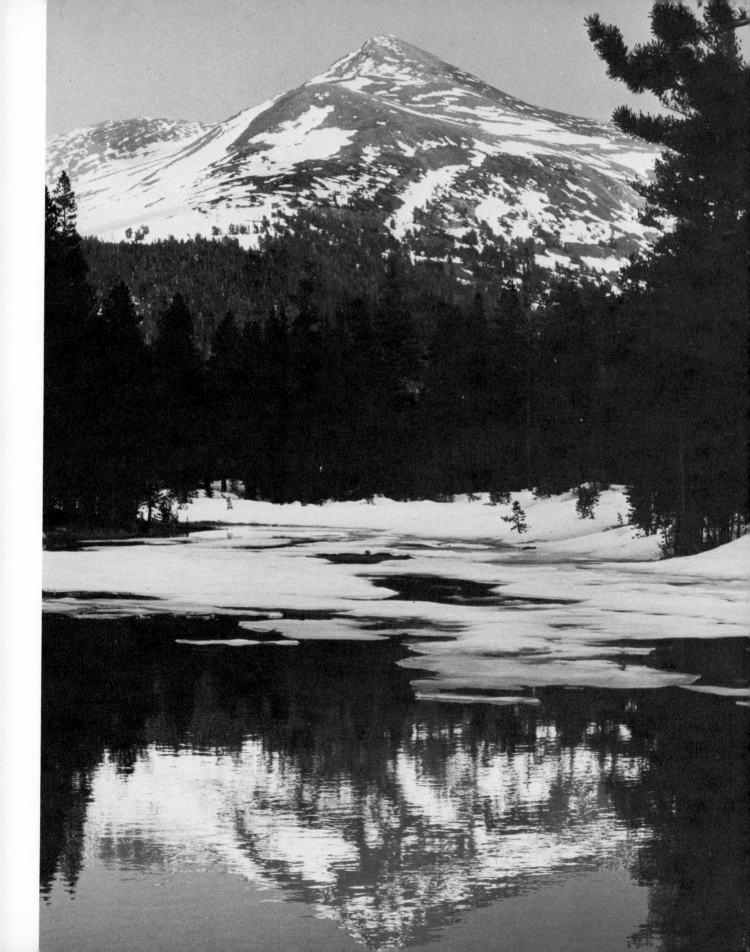

The symmetrical form of this snow-dappled mountain is not so perfect in its reflected image, due to the slightly-disturbed surface of the water. Notice the strong value contrast between the patches of white snow and the blackness of the pine trees.

*Mt. Dana.* Photograph by Niels Ibsen.

Claude Monet, in his winter scene, *The Ice Floe* (1893), uses cool colors and a wispy impressionist painting technique to create a soft reflection in water.

The Metropolitan Museum of Art, the H. O. Havemeyer Collection, bequest of Mrs. H. O. Havemeyer.

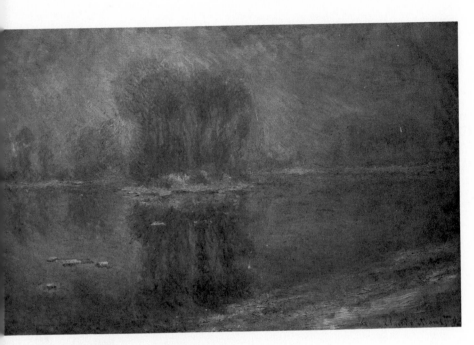

Photographers can also shoot only distorted reflections, leaving out the original source of the reflected image. Can this give you some ideas for abstract reflection paintings?

*Water Design #10.* Photograph by Robert W. Cooke.

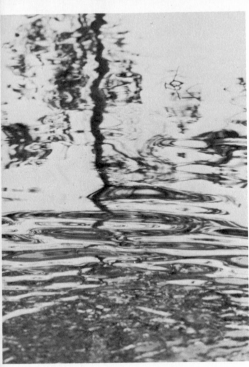

# the shore

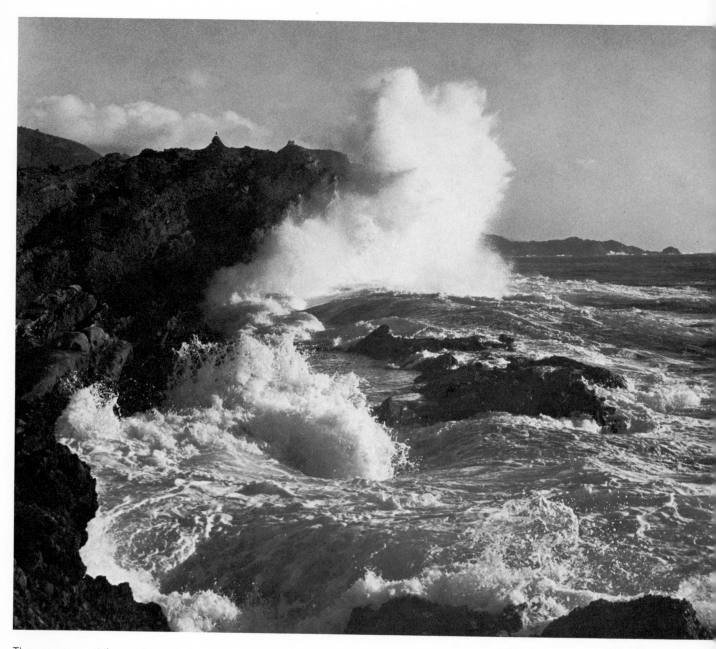

The oceans meet the continental coasts in a constant battle for supremacy. Only seldom is this struggle stilled to a peaceful calm. More often, the water pounds against a stubborn shoreline.

*Coast Waters, Point Lobos*. Photograph by Niels Ibsen.

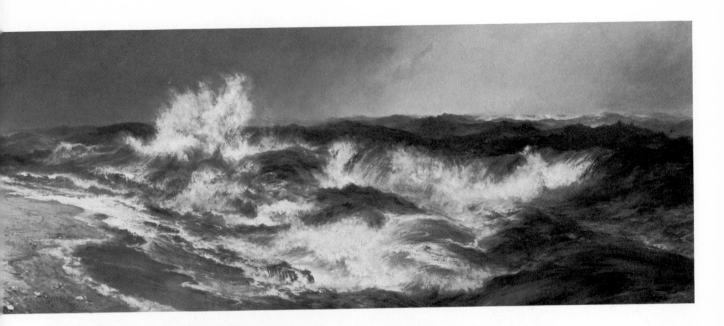

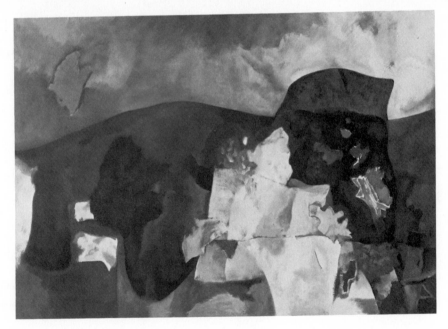

Although there is an absence of rocks, Thomas Moran shows us the fury of an ocean crashing against a sandy beach. The entire surface of *The Much Resounding Sea* (1884) is alive with movement and action.

The National Gallery of Art, Washington D.C., gift of The Avalon Foundation.

Using the elements of crashing sea and stubborn rock, William Brice interprets the struggle in his own way. *Ocean and Cliffs* (1955) is a personal statement, using familiar subject matter.

Los Angeles County Museum of Art, Art Museum Council Fund.

Even from a distance, some coastlines can present a rugged appearance. The palis on the Island of Hawaii are unpassably steep cliffs which face the ocean.

Courtesy Hawaii Visitors Bureau.

In painting *Point Lobos, Carmel* (1914), Childe Hassam used the colors and techniques of Europe's Impressionists. Though the forms seem soft and unstable, squint your eyes to become aware of their actual strength and contrast.

Los Angeles County Museum of Art, Mr. and Mrs. William Preston Harrison Collection.

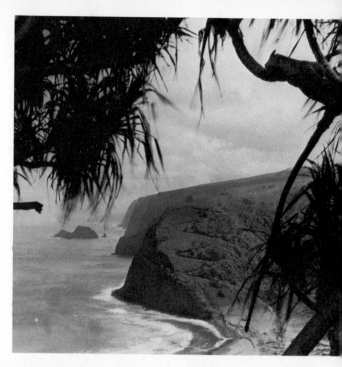

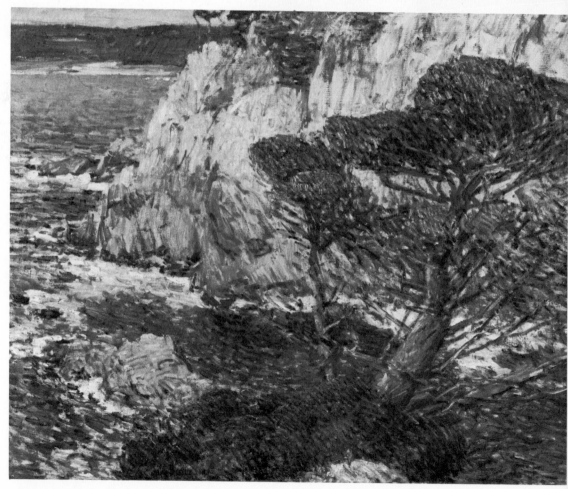

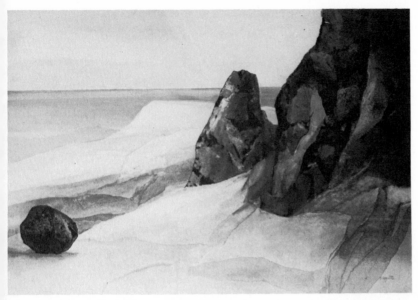

Alexander Nepote emphasizes the strength of coastal rocks in his watercolor and collage painting, *On the Beach — Separated*. Shapes of various papers were torn and glued in place, then colored with transparent watercolor and/or thinned acrylic paints.

Courtesy of the artist and The Emerson Gallery.

Thick ground fog creeps shoreward, over rocks and cliffs, on a cold New England morning. Win Jones used a wet-into-wet watercolor technique to capture the softness of *Coastal Shapes*.

Collection of Ms. Diane Skamfer. Photograph by Barry Stark.

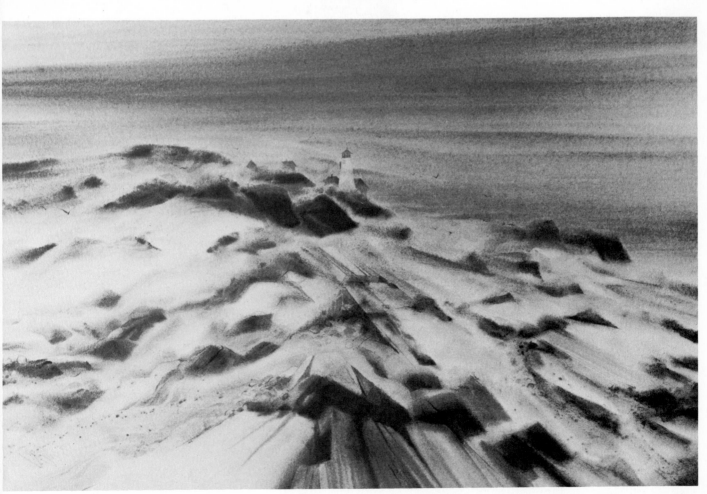

The afternoon sun glares white as it is
reflected from the sea. Dark rocks provide
a severe contrast of values and dramatize
the composition. Notice the similarity of
subject, shapes, values, pattern, textures
and perspective in Edward Betts' painting.

*Hurricane Point.* Photograph by Niels Ibsen.

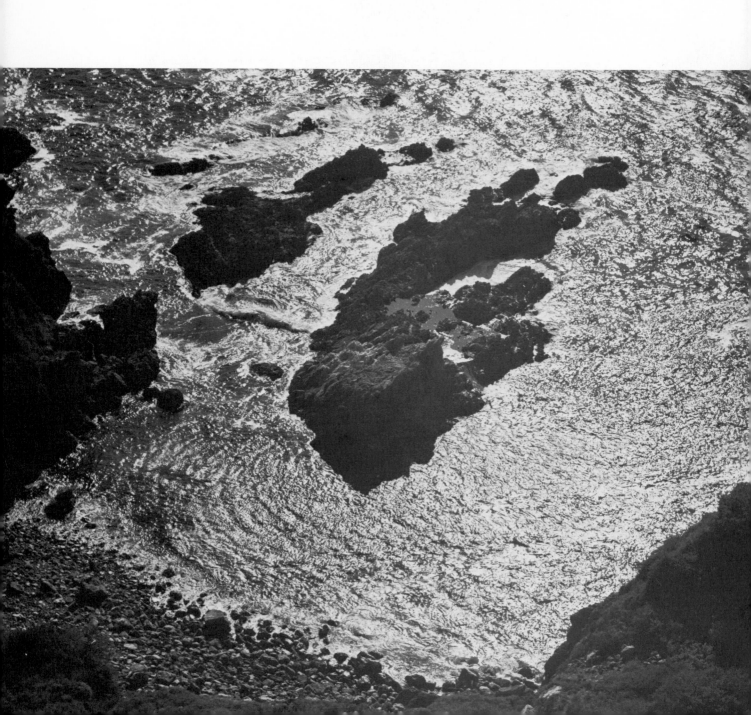

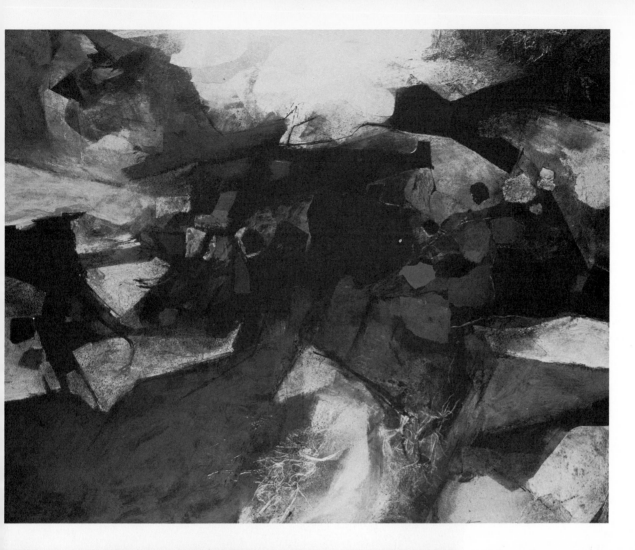

Using collage and mixed media, Edward Betts paints a close-up view of the *Stormy Shore*. Rocks and rushing water create an exciting composition in what seems an almost-vertical view of the scene.

Private collection, courtesy of the artist.

Phil Dike has combined the various coast-al elements into a tiered arrangement. In *Sea Structure #15,* sky, water, sand, surf and rocks are painted in the personal watercolor style of the artist.

Courtesy of the artist.

67

Though the shore is now calm and serene, the partially buried driftwood and the ridges on the sand dunes give evidence of the fury of both wind and water.

Courtesy Florida Department of Commerce.

Milton Avery has simplified the shapes of rocks, ocean and surging water in his oil painting, *Sunset* (1952). Textures and line were of little concern, while emphasis was placed on shape, value and color.

The Brooklyn Museum, gift of Roy R. and Marie S. Neuberger.

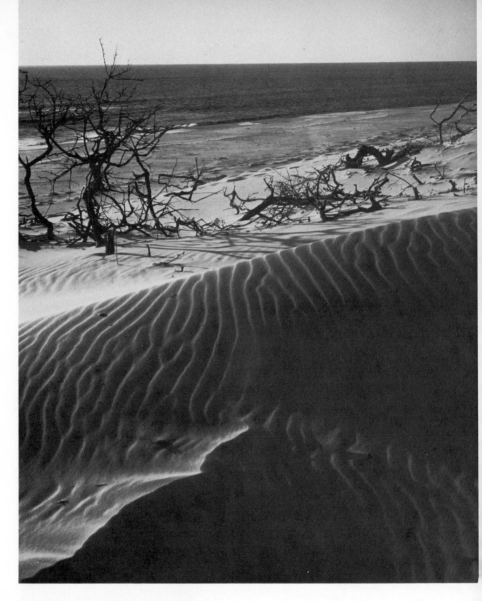

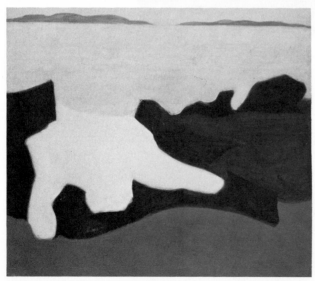

Max Ernst interprets the shore in his own expressionistic way. *La Mer* (1925) contains all the elements of a coastal scene (sky, sun, water, sand), but the artist has developed personal symbols to show each of them.

Los Angeles County Museum of Art, Mr. and Mrs. William Preston Harrison Collection.

Helen Lundeberg works with graceful, free-flowing shapes, arranging them to fit her exacting design needs. Often, as in *Summer Tide,* the resulting arrangement suggests a landscape or seascape, but no actual site is the subject matter for the work.

The Hirshhorn Collection, courtesy of the artist.

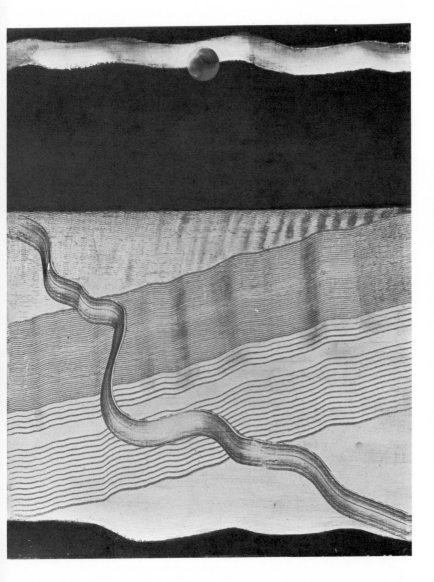

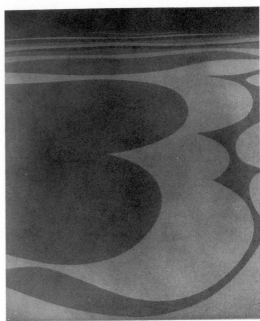

# sky

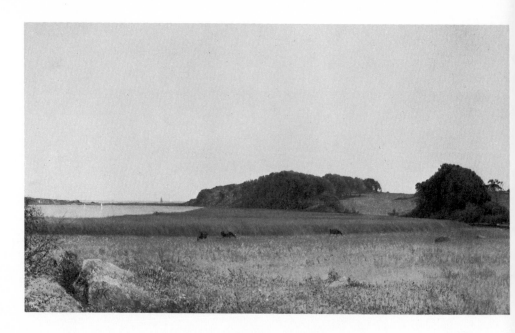

Often the space above us is empty of clouds, which can add a feeling of serenity to our landscape. John Frederick Kensett painted *An Inlet of Long Island Sound* (1865) with a bright but empty sky space, which emphasizes the landscape features.

Los Angeles County Museum of Art, gift of Colonel and Mrs. William Keighley.

The air above our landscape can simply be negative space behind trees, mountains or rocks. But more often it is filled with clouds or fog that drastically change the mood and shape of the scene.

Fog and mist obscure distant hills and trees. Billowy clouds hang heavy over a summery mountain landscape. Storms can add intense drama to an otherwise neutral scene. The sunlight on a clear day will differ in intensity and color from the light on an overcast day.

Artists must be concerned not only with the shape and form of clouds, but with their effect on the light, value, color and dramatic content of the work. Clouds change momentarily and artists can use them to add mystery and/or drama to a painting. They can be sunny, full of rain, powerful, wispy, high, low, soft, stern, dark, light and ever changing.

Notice how artists have used skies to set the stage for their work. The placement of the eye level (horizon line) determines whether there will be much sky or very little. Because clouds and skies are so changeable, artists can manipulate them to suit their pictorial needs in each work. They can be moved, shifted, darkened or eliminated, depending on the changing needs of the artist.

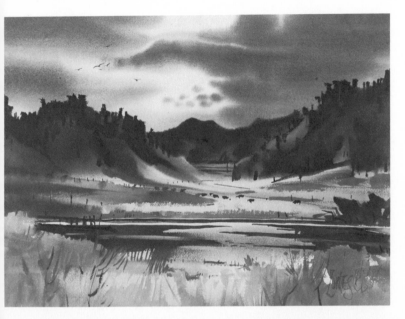

In *Storm over Alton,* Milford Zornes used a wet-into-wet technique to create an interesting sky above this landscape. Imagine the same scene with a clear sky to see how the artist can change the mood of the painting by changing the color, values and shapes in the sky.

Collection of Mr. and Mrs. Harold Ford.

The drama of a golden sunset is used by Rembrandt van Rijn to add excitement to his painting, *The Mill.* Dark and shadowy areas provide the contrast (even in the sky), while the windmill, piercing the luminous sky, becomes the center of interest.

National Gallery of Art, Washington D.C., Widener Collection.

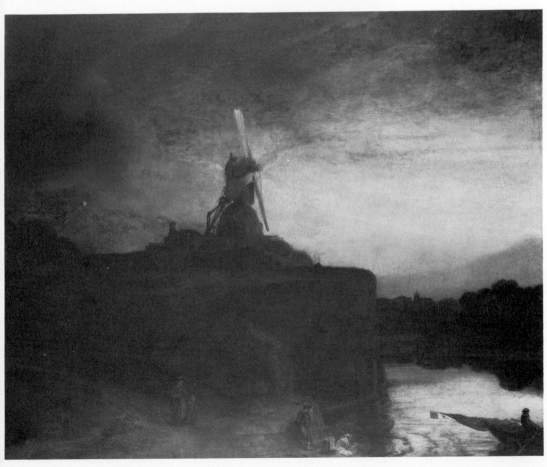

# clouds

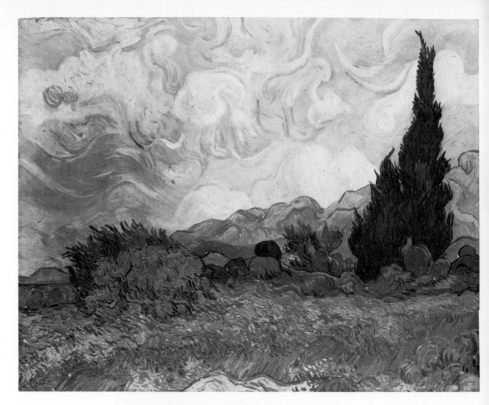

To Vincent van Gogh, the world was filled with commotion, and his skies depict swirling movement. Compare *Wheat Fields and Cypress Trees* with the Skylab photo. Because of the action in the clouds, the sky becomes part of the positive space in the landscape.

The National Gallery, London.

Although clouds often seem gentle and quiet, a Skylab view of a South Pacific storm gives you an idea of the constant and violent action in a storm system. The sky seems alive with motion.

Photograph, courtesy NASA.

The slant of the clouds gives you a clue as to the direction the wind is blowing. Notice that the sky is darker above, and lighter as it nears the horizon. Put a bit of white paper over the sky, and see what a change in mood takes place immediately.

Photograph by Niels Ibsen.

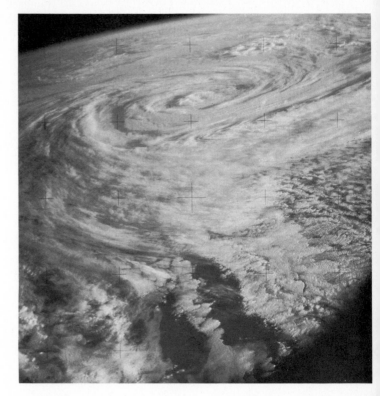

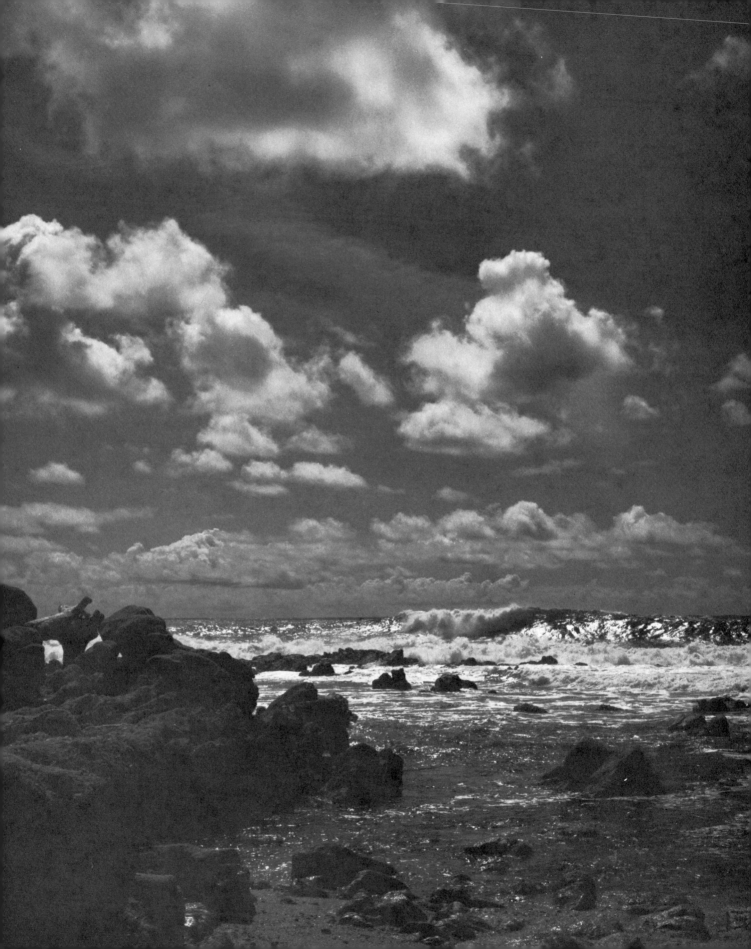

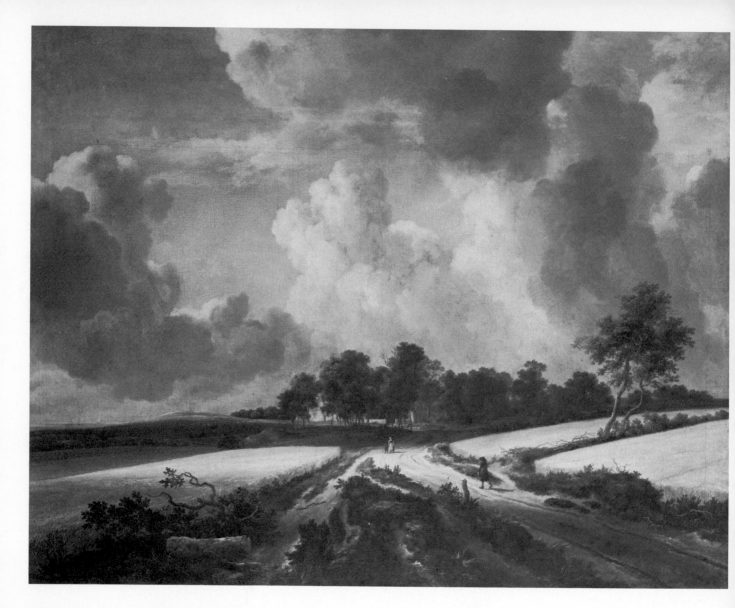

Seventeenth Century Dutch painters often filled huge sky space with billowing clouds, adding drama to flat and uninteresting landscapes. In *Wheatfields,* Jacob van Ruisdael piles cumulus clouds in varying values above Holland's fields and trees.

The Metropolitan Museum of Art, New York, bequest of Benjamin Altman.

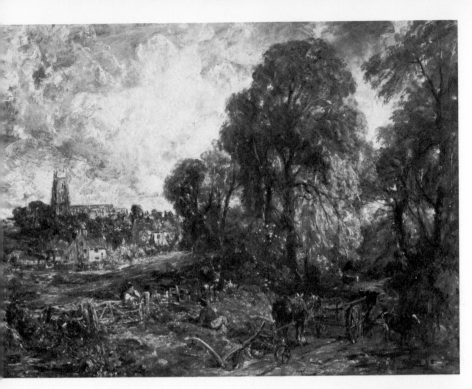

John Constable made oil sketches from nature and later repainted them on canvas. This on-the-spot sketch (*Stoke-by-Nayland*, 1836) shows not only his rapid use of color and brushwork, but a fascination with the active skies over the English landscape.

The Art Institute of Chicago, Mr. and Mrs. W. W. Kimball Collection.

Rather than paint clouds and landscape with great detail, Alexei Jawlensky simplifies his clouds and mountains into monumental shapes. *White Cloud* (1909) communicates a feeling about the scene, rather than a picture of it.

Norton Simon Museum of Art at Pasadena, the Blue Four-Galka Scheyer Collection.

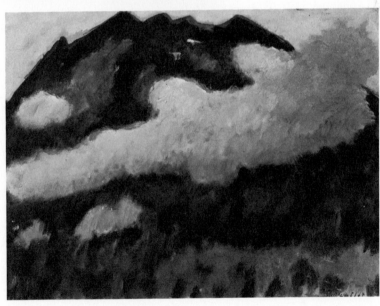

# clouds / drama

Dark skies, either stormy or at night, add a degree of drama and excitement to any landscape. Ralph Blakelock's *Moonlight and Clouds* (1898) is a dramatic landscape in which trees are silhouetted against an active, moonlit sky.

Los Angeles County Museum of Art, gift of Bertram T. Newhouse.

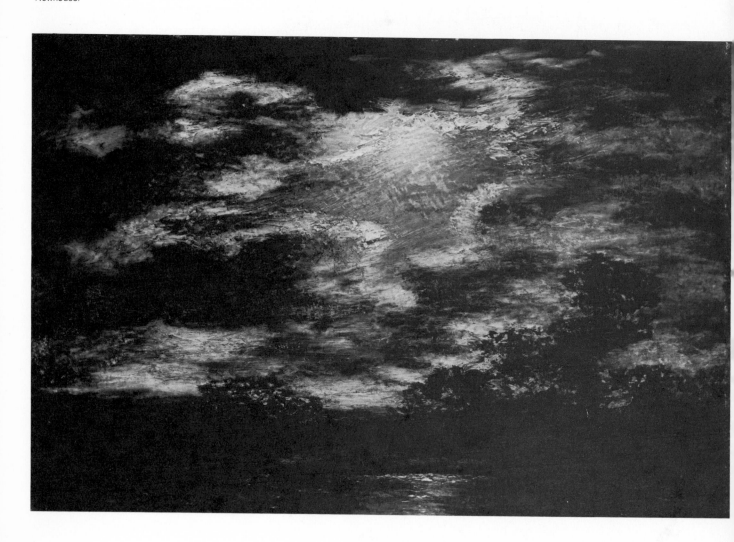

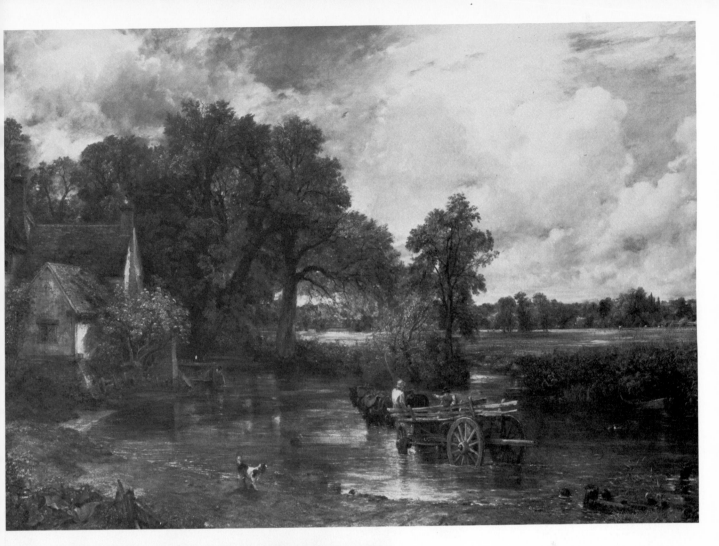

In one of the first important landscape paintings in England, John Constable used massive clouds and huge trees to help show the might of nature and the smallness of humanity. *The Hay Wain* (1821) caused French painters to change their landscape painting techniques and become more aware of the drama in the natural environment.

The National Gallery, London.

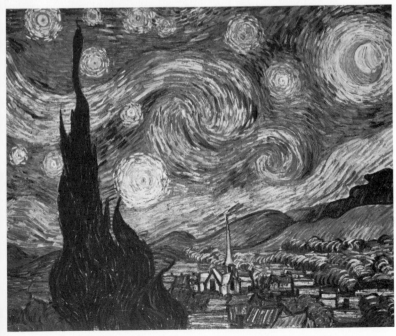

Twinkling stars and churning clouds fill one of the most active skies ever painted. Vincent van Gogh, in *The Starry Night,* expresses a deep feeling about the landscape and night sky, all of which swirl across the canvas with staccato brush strokes.

The Museum of Modern Art, New York, bequest of Lillie P. Bliss.

El Greco used a dramatic sky to add excitement and mystery to his *View of Toledo* (1599). The artist created a mysterious mood and intense feeling about his hometown landscape.

The Metropolitan Museum of Art, The H. O. Havemeyer Collection, bequest of Mrs. H. O. Havemeyer.

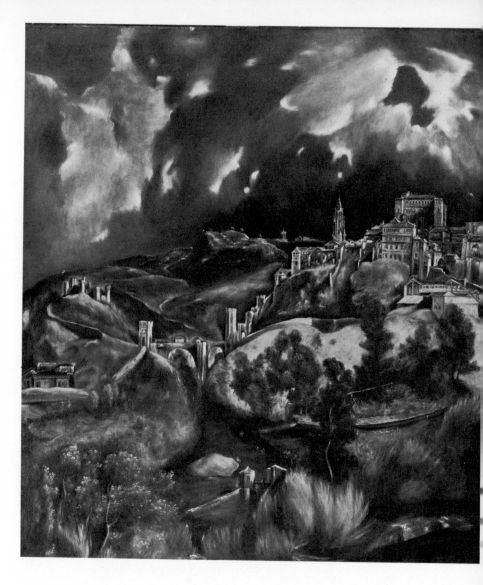

Photographers look for powerful cloud formations and strong value contrasts to add a sense of drama to their work. Niels Ibsen uses a grotesquely-shaped tree to set the stage for an *Approaching Storm*.

Photograph, courtesy of the artist.

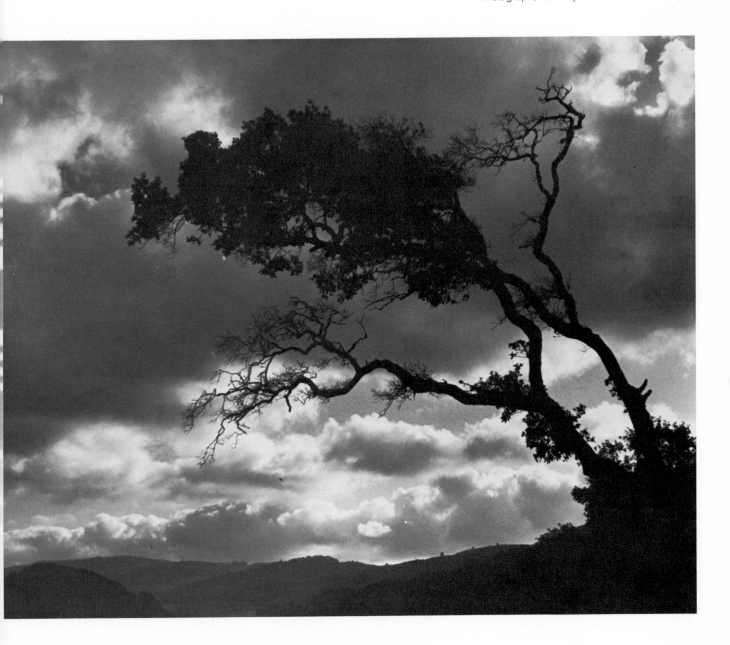

# low and high horizons

Notice how a photographer can use a high horizon line to force your eye into the foreground. As in the Frary painting, a flat landscape can become much more interesting by the use of a high horizon.

Photograph by Dennis Holmes, courtesy Utah Tourist and Publicity Council.

The horizon line is low in Meindert Hobbema's *The Avenue,* but tall trees unite the upper and lower parts of the painting. This work had a strong effect on later English landscape painters, who also filled their huge skies with turbulent clouds.

The National Gallery, London.

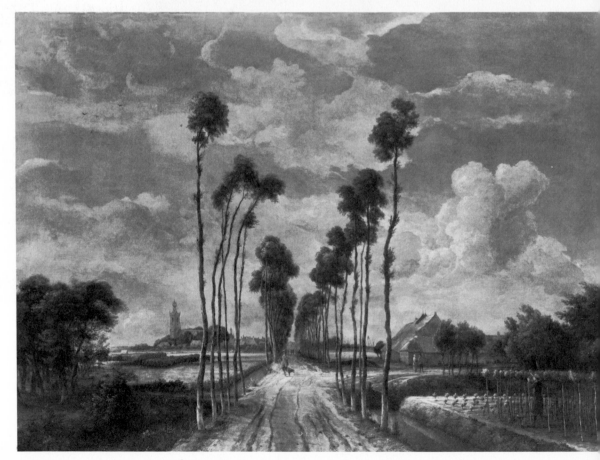

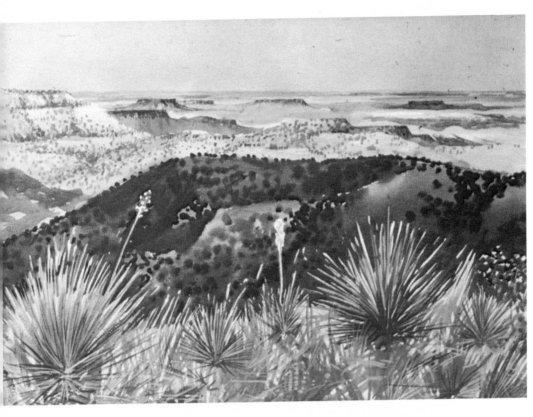

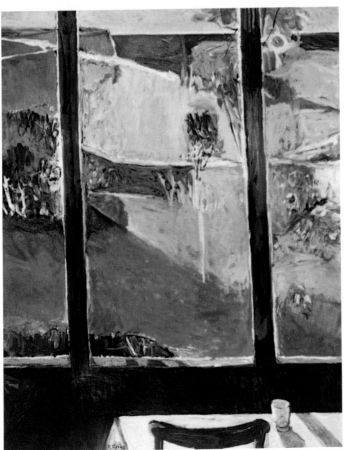

A flat and uninteresting landscape can become more exciting by using a high horizon line and showing more of the foreground material. Michael Frary shows us such a view of the Texas plains.

Courtesy of the artist. From *Impressions of the Texas Panhandle.* Texas A&M University Press.

The sky is only a narrow horizontal strip at the top of Robert Frame's *Red Window*. The artist allows us to see the landscape through a window, as well as part of the house interior. Colors are a personal reaction to the landscape, and are not meant to be actual hues.

Courtesy of the artist.

# storms

Storms usually emphasize the action in the sky and cause the land to play a secondary role. Here, the calm terrain awaits the thunderous action of an approaching storm.

*Pointe de la Heve* (1865) by Claude Monet, is dominated by the heaviness of rain-filled clouds and the peculiar light that accompanies some storms. The artist conveys the feeling of cold and wet in this French coastal landscape.

Kimbell Art Museum, Fort Worth.

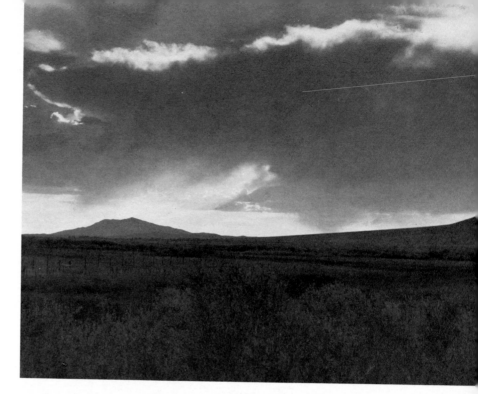

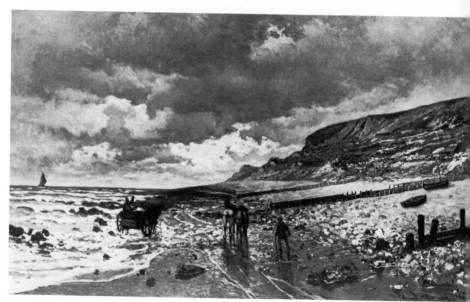

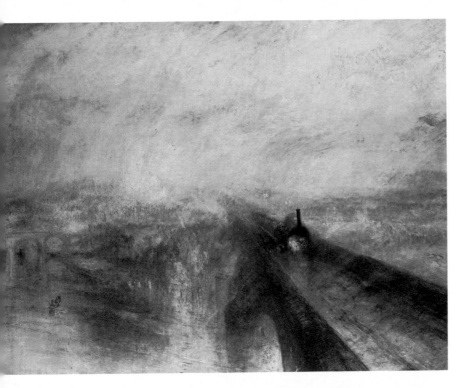

Filtered and dissolving light, shimmering through a misty rainstorm, dominates the painting, *Rain, Steam and Speed* (1844), by Joseph Mallord William Turner. Although an old steam train is crossing an iron bridge, the painting is really about the powerful forces of nature during a driving storm.

The National Gallery, London.

The dramatic action of a storm is echoed in the clouds, trees, figures and value contrasts, in Albert Pinkham Ryder's *Siegfried and the Rhine Maidens*. The overall dark values (low-key) lend a mood of mystery to the work.

The National Gallery of Art, Washington D.C., Andrew Mellon Collection.

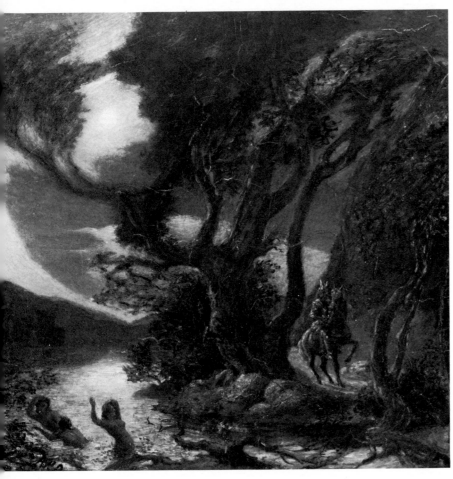

# sunlight

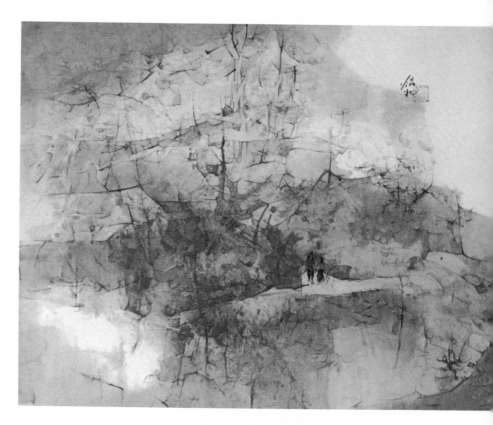

Warm sunlight saturates Kwan Y. Jung's landscape with yellows and oranges. In *Morning, America,* the artist's delicate approach to landscape subjects reflects his oriental heritage.

Collection, Southern Utah City College.

The sunlight in Dan Petersen's *Smokey Jack Creek* is completely controlled by the artist. His crisp watercolor technique emphasizes the bright light reflected from water, rocks and twigs. Notice the value contrasts and the artist's use of colors in the shadows.

Courtesy of the artist.

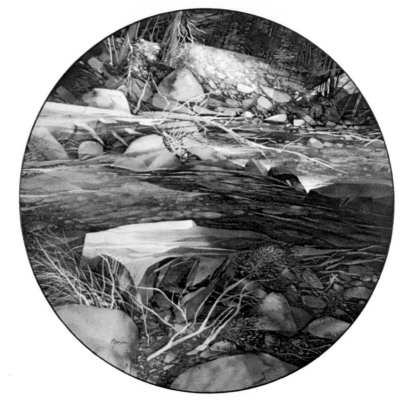

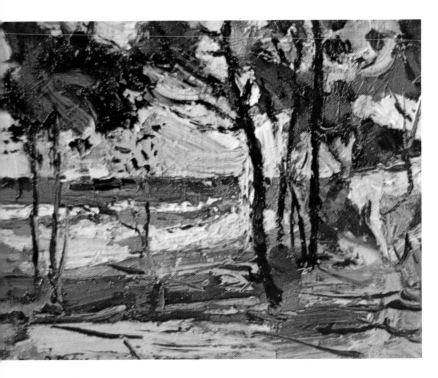

A careful selection of colors reveals the *cool* sunlight of a coastal landscape in Robert Frame's small painting. Heavy application of paint (impasto) reveals the quality of his brush strokes and simplifies both shapes and colors.

Courtesy of the artist.

A warm sunlight bounces from the face of the cliffs, but George A. Magnan uses cool colors to create the shadows in *Rim Country*. Heavy application of acrylic paints (with brushes and knives) enhances the fractured feeling of the rock surfaces.

Courtesy of the artist.

Perry Owen used collaged tissue paper to color his imaginary *Landscape with Sun*. He incorporated the colors of nature, but used fragmented shapes to symbolize landscape features.

Courtesy of the artist.

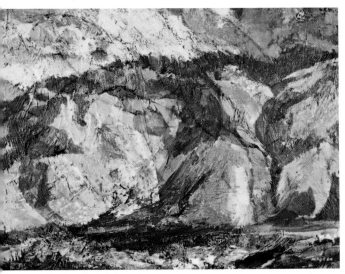

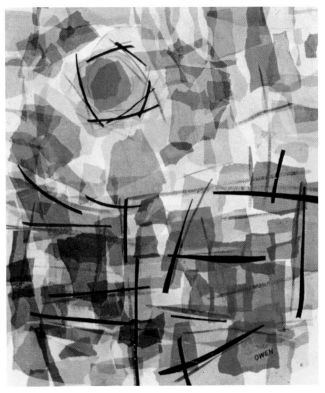

# fog

Distant forms become lighter in value and their edges become blurred and soft, as fog comes between them and the viewer. Mist and fog can help produce a feeling of space and depth in both photographs and paintings.

Photograph by Niels Ibsen.

Though Win Jones does not paint actual places, his watercolor technique in *Rain Images* creates a foggy feeling similar to that in Niels Ibsen's photograph. Notice the softened images and lighter values in the distance.

Collection of Ms. Diane Skamfer. Photograph by Barry Stark.

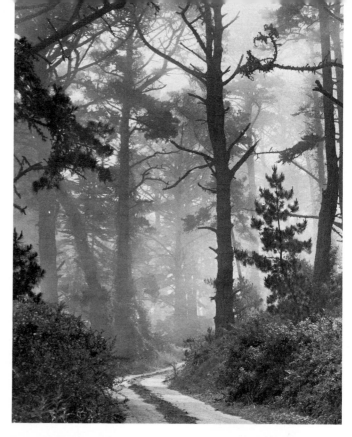

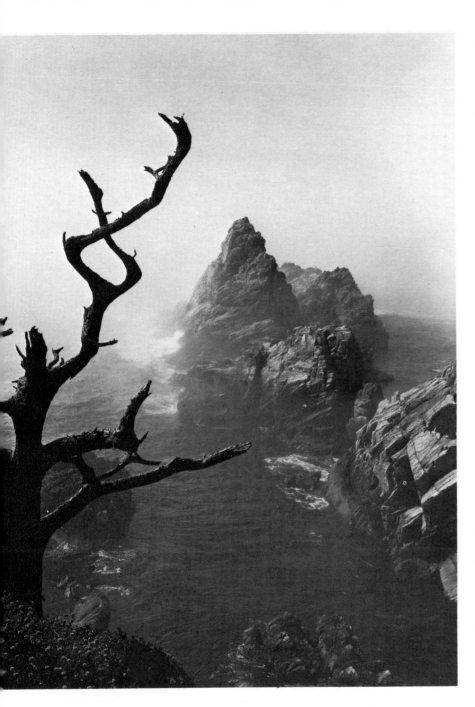

Fog obliterates part of the rocks as well as the horizon line, in this dramatic photograph by Niels Ibsen. Close-up objects retain their sharpness, while distant ones lose all detail.

*Point Lobos Fog*. Courtesy of the artist.

A Pacific fog softens the powerful rock forms of *Palos Verdes Cliffs*, the ink wash painting by Nick Brigante. Extreme value contrasts create a sense of power, even though the edges are soft.

Collection of Mr. and Mrs. Lewis M. Andrews.

# seasons

Spring — A variety of greens, including the light values of new growth, remind us of spring. In Robert Frame's oil painting, the powerful yet abstract forms are seen in a cool light, another reminder of springtime.

Courtesy of the artist.

Summer — Deep greens and a sense of dark, warm foliage and moss fill *Verdant Niche* with summer lushness. Alexander Nepote used both watercolor and acrylic paints to color and texture the collaged surface of his painting.

Courtesy of the artist.

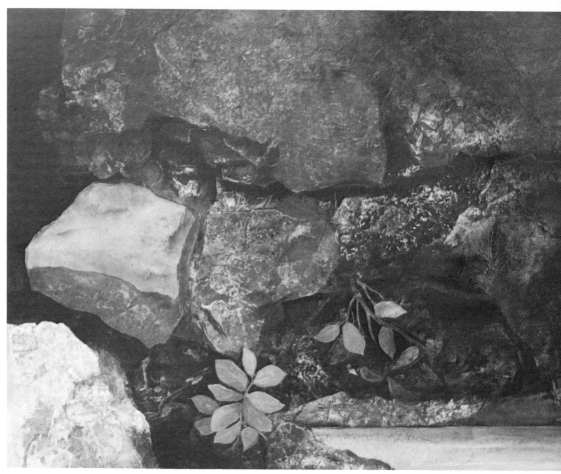

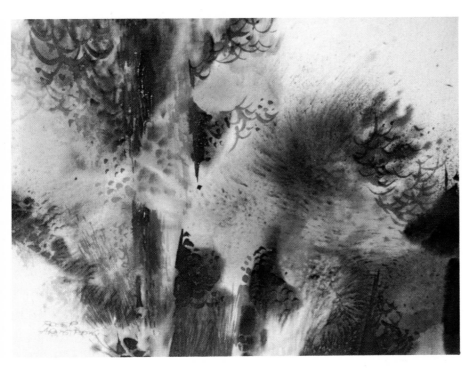

Fall — Bright splashes of typical fall leaf colors are contrasted with the dark forms of trunks and branches. Roger Armstrong's soft wet-into-wet watercolor technique creates the feeling of massed leaves and riotous color.

Collection of Mr. and Mrs. Richard Tom.

Winter — Barren trees, snow and rocks are combined in Pam Hammond's multi-view technique. Gouache and collage are blended in a unique expression of a winter landscape, *It Was February*.

Courtesy of the artist.

# art elements

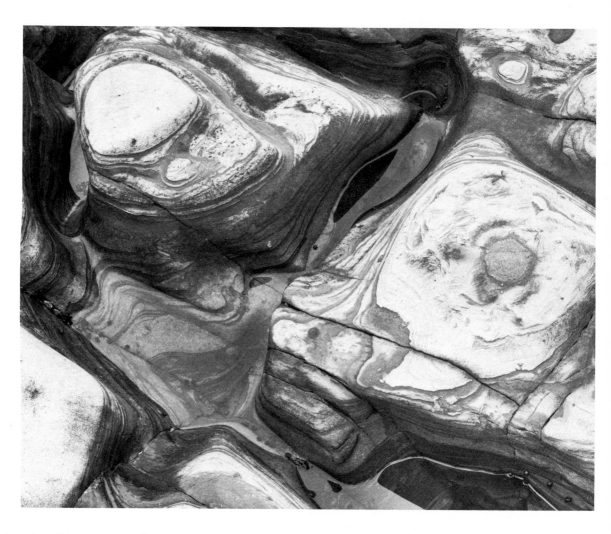

Lines can have a variety of qualities. In this photograph, you may see lines that are thin, wide, dark, light, gray, black, sharp, fuzzy, solid, intermittent, thick and thin, shaded, irregular, smooth, jagged, curved, straight, tapered, shallow, deep — and more.

Photograph by Niels Ibsen.

The elements of design are the raw materials of the artist . . . the visual components of art. They are found in nature as well as in paintings and drawings, and when we become aware of them, we can more easily use them in our landscape work.

Line, color, form, shape, value, texture and space are the elements which the artist employs in producing paintings, prints, drawings or sculpture. How they are used becomes the personal choice of artists after many trials and experiments.

The following pages will help you recognize these art elements in paintings, drawings, prints and photographs.

# line

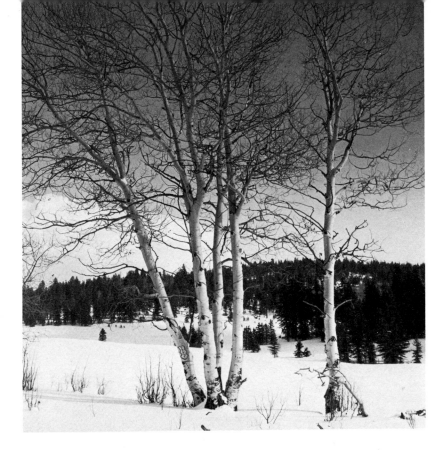

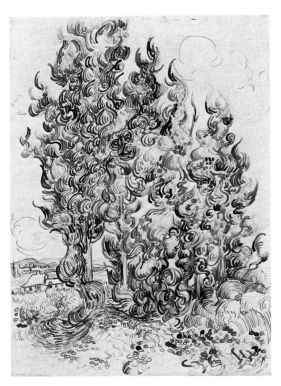

Light lines show up against a dark background and dark lines contrast with a lighter background. These contrasts produce a strong linear quality as branch and twig lines taper into nothingness.

Courtesy Utah Travel Council.

In *Grove of Cypresses* (1889), Vincent van Gogh uses pen, ink, pencil and swirling lines to simulate the twisted foliage of cypress trees. Line is an excellent art element to use in sketching outdoors.

The Art Institute of Chicago, gift of Robert Allerton.

A sharpened stick and India ink were used by Reinhold Marxhausen to stress the linear quality of a thorny lemon tree. Notice how watercolor was added, but the line was allowed to dominate the work.

Collection of Mr. and Mrs. Gerald Brommer.

# color

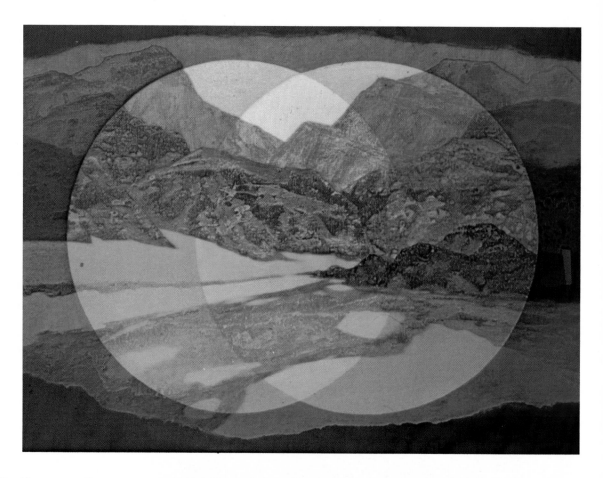

Warm colors dominate *Dual Focus,* an oil painting by Jan Hoowij. The artist has developed a unique method of showing mountain landscapes in a very personal way, combining natural and technological approaches. Such personal colors *(subjective colors)* are used by artists to satisfy special needs in their work.

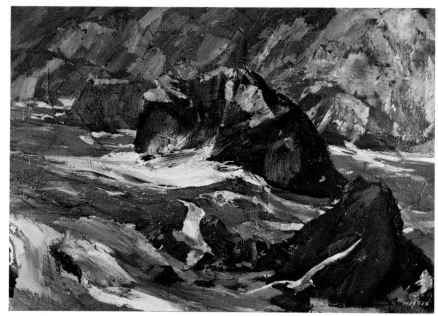

Cool colors are emphasized in George Magnan's acrylic painting of *Monterey Rocks.* Splashes of warm hues help cause the cool colors to seem more intense, and an impasto technique gives life to both rocks and water. *Color values* can be lightened by adding white and darkened by adding black.

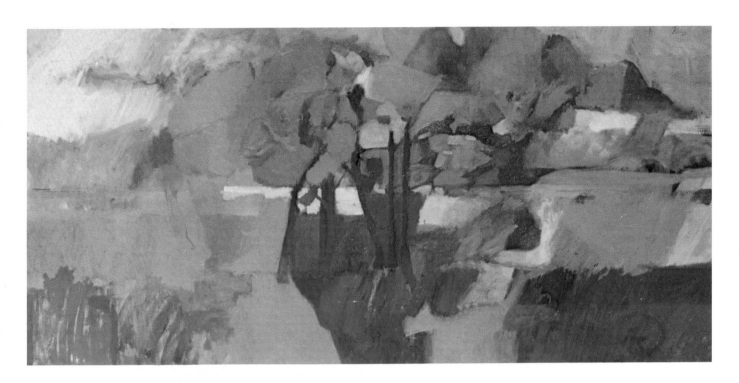

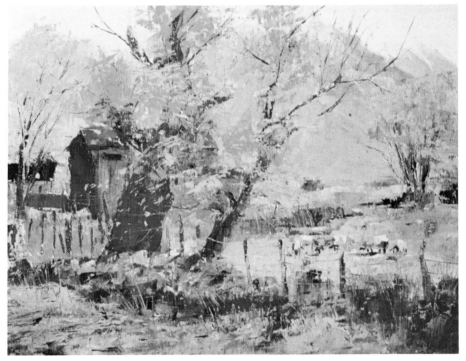

The *complementary colors* (red and green) are on opposite sides of the color wheel, but Robert Patrick Rice features both in his oil painting, *Shade.* By adding a bit of red to some greens, and green to some reds, he has grayed each of them (lessening their *intensities)* and unified the color scheme.

Courtesy of the artist.

Al Dempster worked with a warm range of *analogous colors* (closely related) to capture the warmth of the sunlight in this mountain pasture. Painting knives were used to apply the color and produce the textural surface in *Evans Ranch. Local color,* an important aspect in landscape painting, refers to the colors as they actually are in nature.

# form

Sunlight helps us see the form of things, because it creates shadows and light. Sharp changes in value mean crisp corners and edges, while gradual changes are read as rounded forms.

Courtesy Utah Travel Council.

Contrast in values creates rock forms in *Carmel Rocks and Trees,* a collage and watercolor by the author. Some rocks are rounded, others are angular, and a wide variety in sizes and forms keeps the composition interesting.

Courtesy of the Fireside Gallery, Carmel.

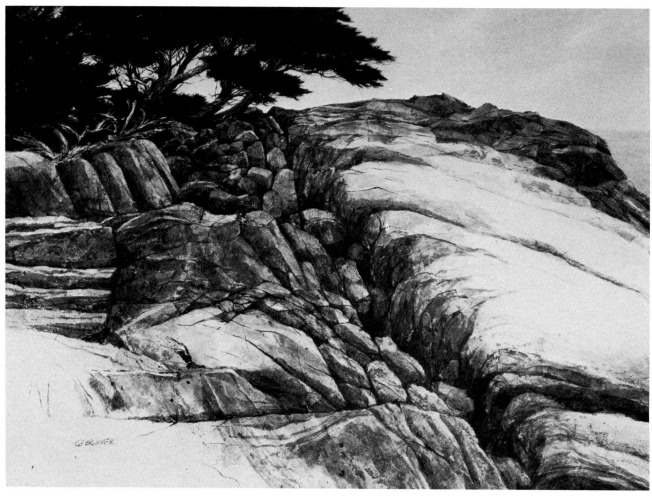

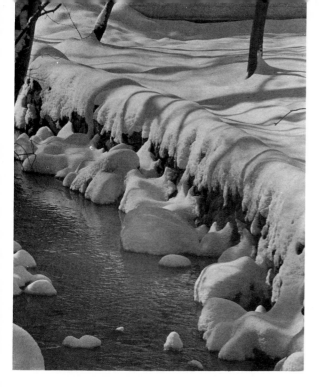

Snow on rocks or trees will simplify the forms by covering details. The shadows cast by trees conform to the surface relief and help us read the earth forms.

Photograph by Robert W. Cooke.

In Diane LaCom's oil painting of *Palo Verde Canyon,* she uses a combination of form and shape. Trees and hills seem rounded, but the flat shapes in both background and foreground force our interest into the central forms.

Courtesy of the artist and the Emerson Gallery.

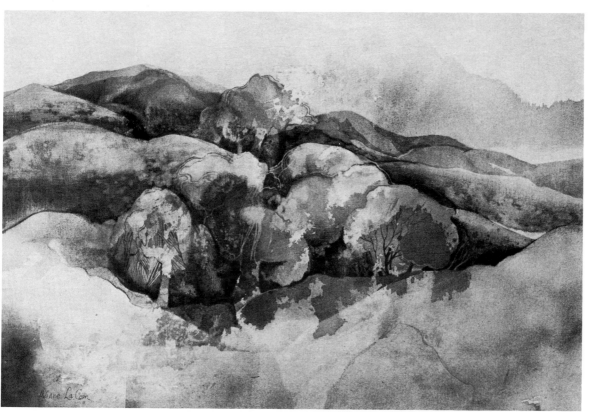

# shape

Shapes have a flat feeling as opposed to the roundness of forms. Perry Owen, in his acrylic painting *Huntington Rocks,* changes round rock forms into flat colored shapes. He has abstracted natural forms into shape and line.

Courtesy of the artist.

Helen Lundeberg begins her painting with large simple shapes that *may* have a relationship to landscape forms. For example, in *Cloud Shadows,* she did not abstract actual clouds, hills and shadow forms, but started with a series of interesting shapes that later suggested clouds, hills and shadows . . . hence the title.

Courtesy of the artist, collection of Mr. and Mrs. Sidney Brody.

96

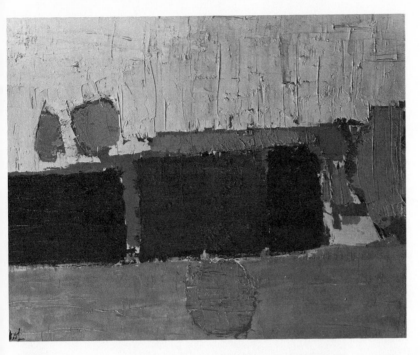

Strong and simply-textured, rectangular shapes were painted by Nicholas de Staël, in a heavy impasto technique. *Landscape in Vaucluse No. 2* (1953) has horizontal movement, a variety of sizes and shapes, and strong value contrasts.

Albright-Knox Art Gallery, Buffalo, New York, gift of Seymour H. Knox Foundation, Inc.

Paul Souza used simple, flat shapes and eliminated all detail from the trunks of these trees. *Sycamores* was painted on the spot, using actual trees as models, but the subjects were abstracted into these basic shapes. Contrasting values suggest space and depth.

Courtesy of the artist.

Silk screen prints, such as this tropical landscape, use simple flat shapes to good advantage. In this student serigraph, five paper stencils were used to screen the five bright colors.

Lutheran High School, Los Angeles.

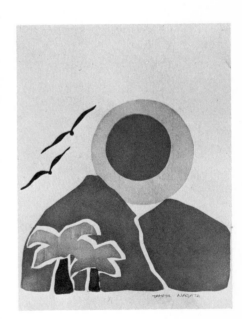

# value

Gustave Courbet used mostly dark values in his oil painting, *The Pool*. Low-keyed paintings, such as this, use black in combination with colors to obtain the intense, dark values.

Los Angeles County Museum of Art, Paul Rodman Mabury Collection.

Claude Monet used mostly light values in painting *Veltheuil: Sunshine and Snow*. Hues are combined with white to produce the high-keyed colors of a bright winter day.

National Gallery of Art, London.

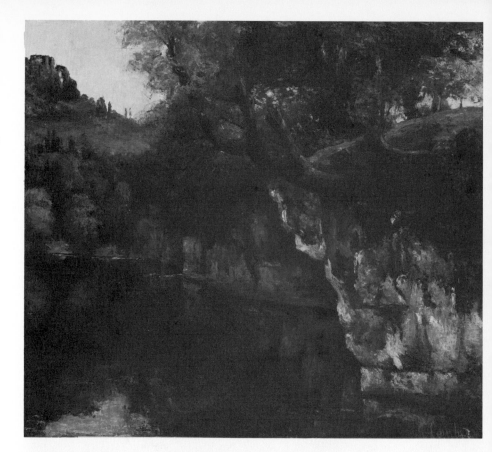

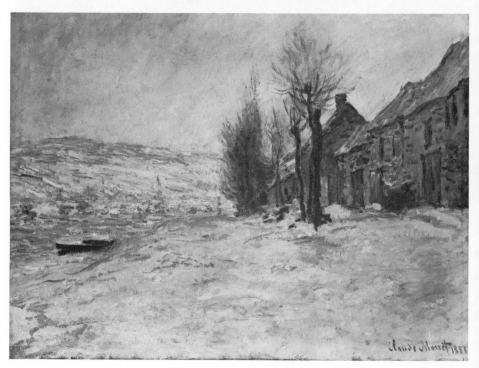

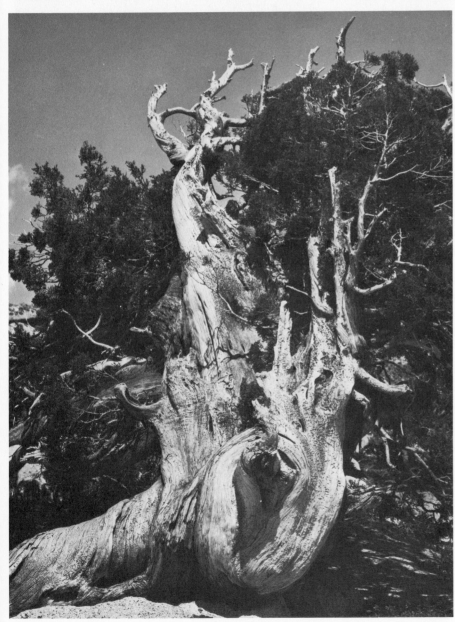

Value refers to a full range of grays, from white to black. When a full color painting is photographed in black and white, the gray values are easily noted. To check for a range of values in a painting, squint your eyes and concentrate on dark and light contrasts. In *Winter Seas*, Edward Betts has used a complete range of values.

Private collection, courtesy of the artist.

Photographers who work with black and white film must be very conscious of value contrasts. Niels Ibsen produces a strong composition by setting a light-valued, twisted tree form against a dark-valued background of pine foliage.

Courtesy of the artist.

# texture

The swirling textures of tortured wood growth is intriguing to study. *Knurled Root* emphasizes the tactile quality of such surfaces in nature.

Photograph by Niels Ibsen.

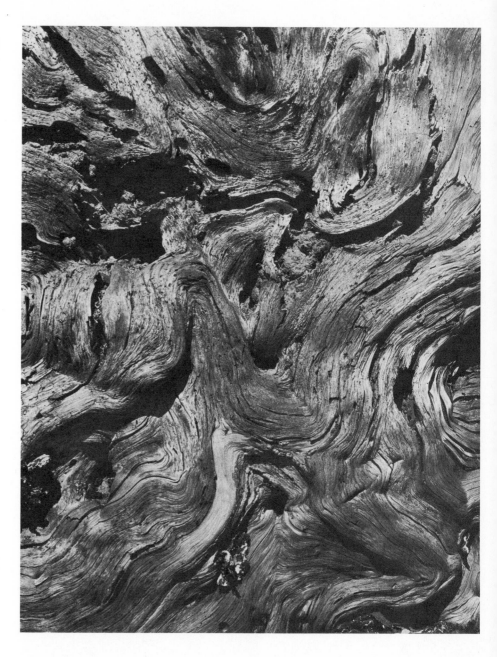

Ben Shahn used thousands of brush marks to create the textural surface of *Pacific Landscape.* The figure and water contrast with the sand in this tempera painting, adding a sense of relief from the overall textural quality of the beach.

Museum of Modern Art, gift of Philip L. Goodwin.

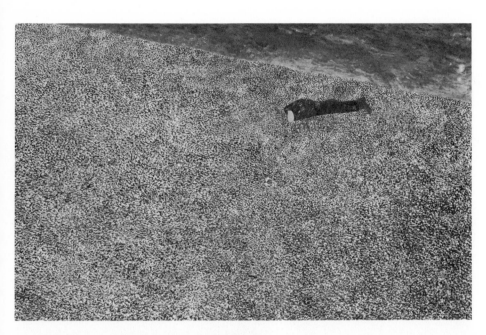

Painting knives were used by this student to create a richly textured surface. Trees, grass, branches, stream, sunlight and shade are all given a similar textural quality, which creates a strong feeling of unity in the work.

Lutheran High School, Los Angeles.

Thickly painted brush strokes can create an actual texture which you can feel with your fingers. The surface of *The Olive Orchard,* by Vincent van Gogh, swirls with textures which actually reflect light and cast shadows.

National Gallery of Art, Chester Dale Collection.

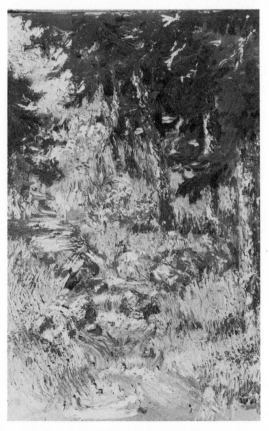

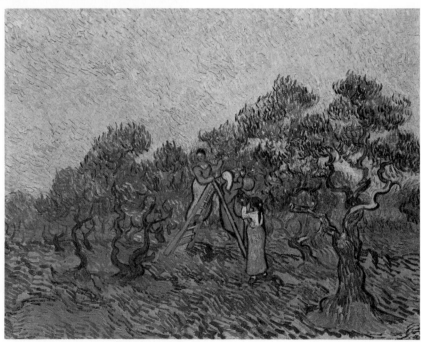

# space

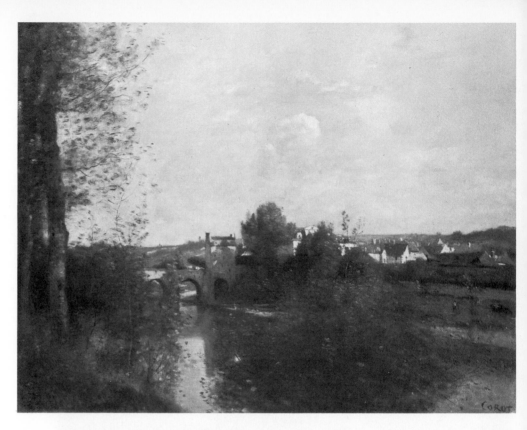

By looking past nearby trees, the artist places the town in the middleground. Notice how the distant background loses detail and sharpness. *Limay* (1872) is an oil by Jean-Baptiste Camille Corot.

Los Angeles County Museum of Art, Paul Rodman Mabury Collection.

By placing the eye level high in the painting, Georges Seurat creates a sense of depth. Boats getting smaller in the distance reinforce the feeling of space. *Port-en-Bessin, Entrance to the Harbor* (1888) is a pointillist painting, produced with countless dots of color.

Museum of Modern Art, Lillie P. Bliss Collection.

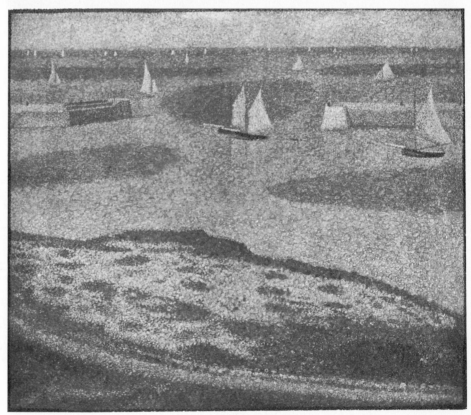

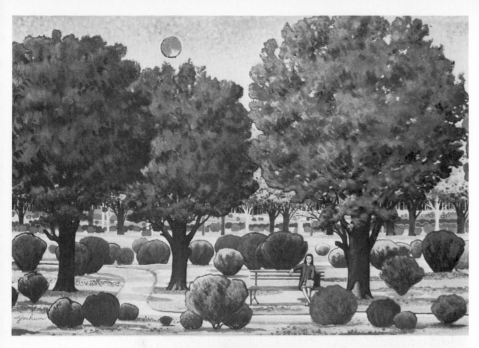

Overlapping shapes are combined with diminishing sizes in the distance to create a strong sense of depth in Delmer J. Yoakum's *In the Park*. The bases of more distant bushes and trees are also higher in the painting, which strengthens the illusion of space.

Courtesy of the artist, photograph by Cricklewood.

Dan Petersen uses strong and controlled visual movement to direct your eye into the distance. Enter at the lower right and feel your eye move over the surface to a distant point in space.

*Tamarack Trail*. Courtesy of the artist.

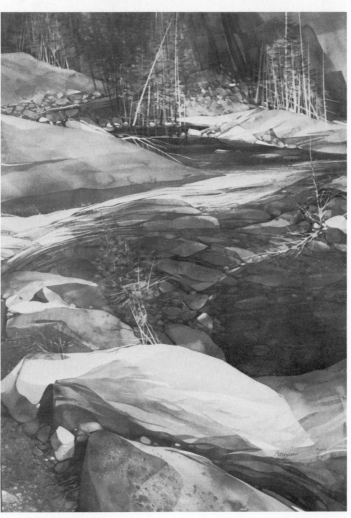

# using imagination

The space in Nicholas de Staël's oil, *Vue de Marseilles,* is broken into generally rectangular blocks of color. Sky, earth, water and natural forms are reduced to their simplest shapes and arranged to satisfy the artist's personal feelings.

Los Angeles County Museum of Art, gift of the estate of Hans de Schulthess.

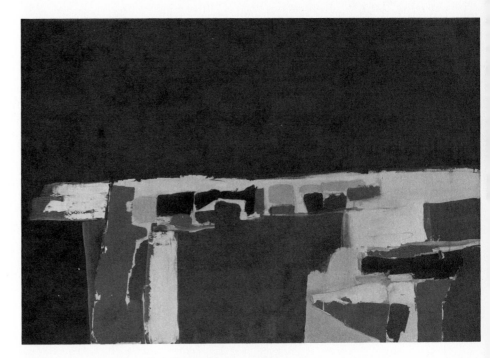

All of the artists, from students to masters, have used imagination in the work shown in this book. Whether they worked from nature, an idea, a sketch or a photograph, they have interpreted the natural landscape and created personal statements. Some have worked realistically, others abstractly, and many painted or drew someplace in between these ultimate extremes. But all have exercised imagination.

Some artists may begin with the seed of an idea, extracted from nature. Others may rearrange natural elements to fit their design needs. Still others may distort, extract, simplify, elaborate on, or simply use natural features, yet produce work which is completely different from nature.

Artists may want to create the moods, colors, light, shapes or feelings of a site, rather than reproduce it exactly. Some artists may imagine fantastic landscape scenes which never even exist on this planet. The more you become familiar with the features of the natural landscape, the more liberties you may wish to take in creating your own paintings, sculpture, drawings or prints.

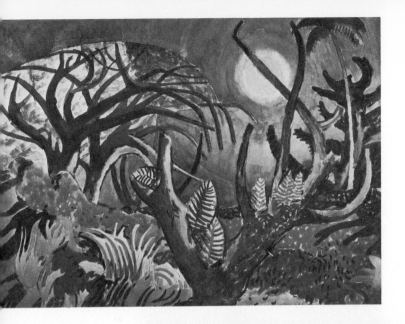

# designing your own space

You may recognize trees and foliage in Millard Sheets' watercolor, *High Mountain Country.* Yet the artist has taken natural vegetation and rearranged it to fit his designed space. Lines, shapes, color and movement are woven together in a carefully composed design.

Collection of Mr. and Mrs. Gerald F. Brommer.

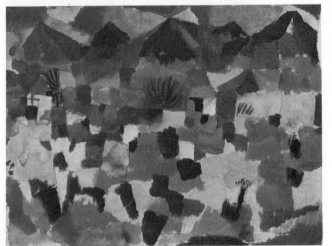

Paul Klee extracted characteristic shapes and colors from his landscape source, and eliminated all features which he did not wish to include. *Tunisian Gardens* (1919) is the simplified result. Notice how the repetition of various shapes produces a constant rhythm in this watercolor painting.

Norton Simon Museum of Art at Pasadena, the Blue Four-Galka Scheyer Collection.

The squarish shapes of coastal rocks, a dazzling sea, and the shimmering sun are expressed by Phil Dike in the watercolor, *Big Sur Moment.* In rearranging the various landscape elements, the artist must use imagination and a keen knowledge of design to make a personal statement.

Courtesy of the artist.

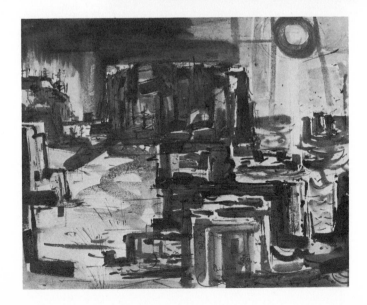

# surrealism

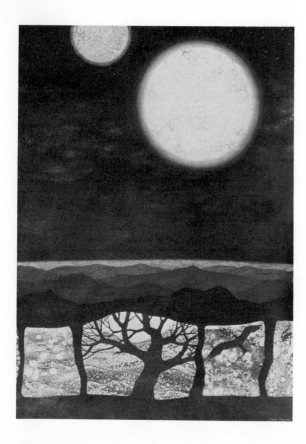

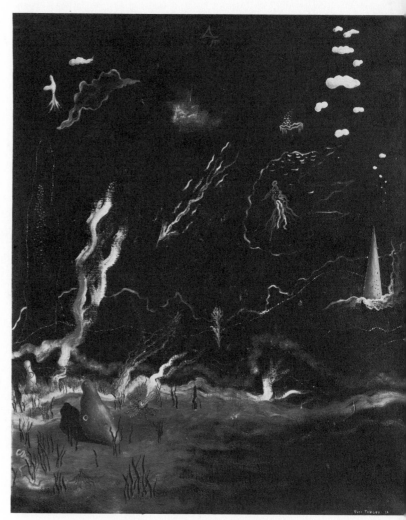

Jan Hoowij uses easily recognizable landscape features such as moon, trees, flowers and hills, but arranges them in his own personal way. *Above and Below* is painted in intense colors, with deep blue predominating.

Courtesy of the artist, and the Emerson Gallery.

Yves Tanguy works with forms that may seem realistic, but on close examination are purely imaginary. *The Storm* (1926) might be taking place on another planet, yet light, space and form seem almost earthly.

Philadelphia Museum of Art, Louise and Walter Arensberg Collection.

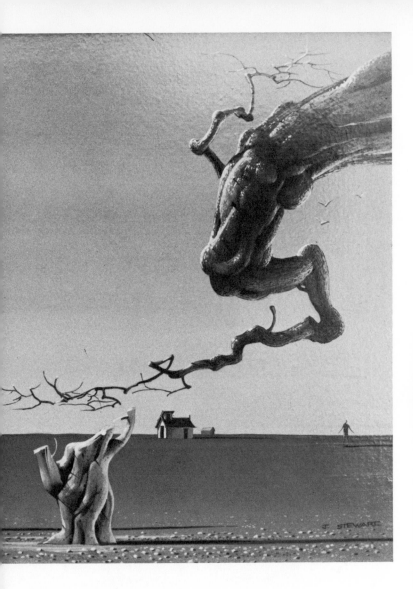

Carefully rendered landscape features are used in unnatural ways in *Deep Space,* the oil painting by John Stewart. Such surrealistic effects are achieved by a fertile imagination, coupled with a knowledge of landscapes and the ability to paint them realistically.

Courtesy of the artist.

Flying through swirling clouds has set David Halperin's imagination to work. His serigraph *As It Was in the Beginning* has both a realistic and a completely abstract feeling that also stimulates the viewer's imagination.

Courtesy of the artist.

# imagination

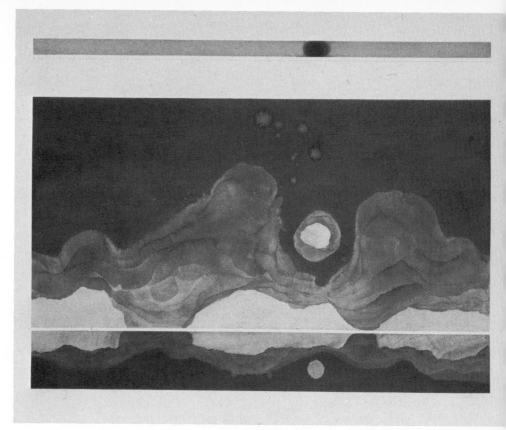

Although Robert Perine's painting, *Pre-flections II,* has the feeling of landscape, it is completely imaginary. Colors, shapes and values seem based on reality, but landscape is not considered when the artist is designing and working on his paintings.

Courtesy of the artist.

Using an actual tree only for visual reference, Piet Mondrian invented his own *Tree* (1912), in a symmetrically balanced design. He emphasized some branches and eliminated others in arriving at his personal statement about rearrangement of trees.

The Museum of Art, Carnegie Institute, Maillol-Mondrian Fund.

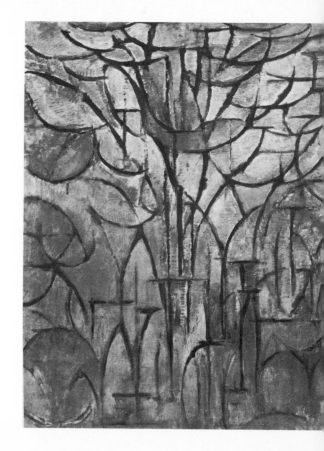

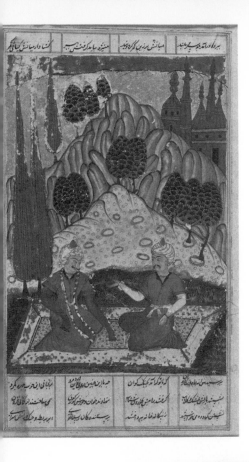

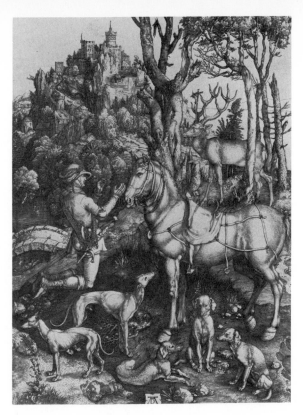

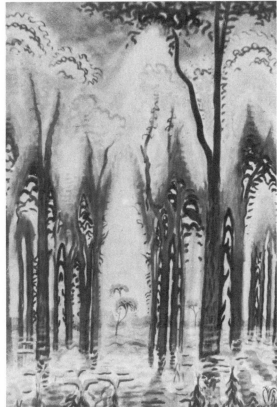

No hills or trees ever looked like those in this Sixteenth Century painting from Northern India. In *Two Men Converse in a Landscape,* the artist worked in a style that was dominant in his time. He used imagination more than actual landscape elements.

From *The Folio from a Shah Nama.* Los Angeles County Museum of Art, gift of Doris and Ed Wiener.

Albrecht Dürer had a fertile imagination but also sketched constantly from nature. Both are evident in this engraving, *The Vision of Saint Eustache* (1501), where an imaginary landscape forms the background for an imaginary happening.

Los Angeles County Museum of Art, Graphic Arts Council Fund.

Charles Burchfield's landscapes tell us more about nature than simply its shapes and colors. His expressionistic watercolor, *September Glade,* shows the sheer pleasure of nature and its constant vibration with new life.

Collection of Concordia College, Nebraska.

# index

# acknowledgments

Many people have contributed time and energy to help put this book together, and we hope that readers will benefit from our combined efforts. Artists have been overly-generous in sending more work than I sought, and have enriched these pages by sharing their work. I am deeply appreciative to: Roger Armstrong, Edward Betts, Nick Brigante, Al Dempster, Phil Dike, Eyvind Earle, Robert Frame, Michael Frary, Ray Friesz, George Gibson, David Halperin, Pam Hammond, Jan Hoowij, Win Jones, Kwan Jung, Mary Jane Kieffer, Diane and Wayne LaCom, Helen Lundeberg, George Magnan, Reinhold Marxhausen, Alex Nepote, Perry Owen, Robert Perine, Dan Petersen, Robert Patrick Rice, Millard Sheets, Paul Souza, John Stewart, Lee Weiss, Richard Wiegmann, William Wolfram, Robert E. Wood, Delmer Yoakum and Milford Zornes.

Museums are a natural source for historical paintings that document the progress of landscape painting. The following people and museums were most cooperative in providing me with photographic prints of work in their collections. My sincere thanks to Ann Blyth, the National Gallery, London; Barbara Josefa Bradley, The Art Institute of Chicago; Philippa Calnan, Los Angeles County Museum of Art; Sara Campbell, Norton Simon Museum of Art at Pasadena; Kathleen M. H. Ewing, National Gallery of Art, Washington D.C.; Rosamond Hurrell, The Minneapolis Institute of Arts; Arno Jakobson, The Brooklyn Museum; Irene Moore, Philadelphia Museum of Art; Rita Myers, The Museum of Modern Art, New York; Alba Priore, Albright-Knox Art Gallery, Buffalo; Nada Saporiti, The Metropolitan Museum of Art, New York.

Some colleges, universities, galleries and state agencies also shared some work from their collections. My special thanks to Candace Adams of the University of Texas Press; Concordia Teachers College, Seward, Nebraska; The University of Texas at Austin; Ruth Hatfield at the Dalzell Hatfield Galleries in Los Angeles; Wayne LaCom at the Emerson Gallery in Tarzana, California; Richard Challis at the Challis Galleries in Laguna Beach; John E. McLeaish, National Aeronautics and Space Administration; Bill Spigel, Utah Travel Council; Karen Smith, Texas Tourist Development Agency; Paul Stahls, Jr., Louisiana Tourist Development Commission; Joice Veselka, Florida Department of Commerce; Dona Welch, Vermont Agency of Development and Community Affairs; and the Hawaii Visitors Bureau.

Recording actual scenes of our natural landscape falls into the hands of photographers. Jack Selleck and Robert Cooke provided me with essential work from their collections. I looked for photographers who were keenly aware of the natural landscape and were tuned in to the concepts I wished to present. Many were consulted, but most generous and most capable seemed to be one of Carmel's finest, Niel Ibsen. My special warm and sincere thanks to him for enriching the book and our lives with his sensitive and superb photography.

And a final and special thanks to my wife, Georgia, who knows just when to help and just when to leave me and my typewriter alone.